BLEEDING EDGES

Artworks by Danni Shinya Luo
Written by Danni Shinya Luo
Cover Quote by Lisa Liang
Book Design by Lilly Tomás

Rocketship Entertainment, LLC

Tom Akel, CEO & Publisher
Rob Feldman, CTO
Jeanmarie McNeely, CFO
Brandon Freeberg, Dir. of Campaign Mgmt.
Phil Smith, Art Director
Jed Keith, Social Media

rocketshipent.com

REDEEMABLE NFT

Scan this code to redeem your free Bleeding Edges NFT.*

* You must have your receipt or order number and an Ethereum wallet in order to redeem. One per customer.

BLEEDING EDGES

DANNI SHINYA LUO

ROCKETSHIP ENTERTAINMENT

TO YOU WHO PICKED UP THIS BOOK

Whether it was from a physical store, at a convention booth, or online; a connection is formed between you and me. Every hour every minute, people all over the world are connecting in all sorts of ways. This is a moment where you the collector, and I the creator, connect.

We may not ever get a chance to know each other in real life. But through viewing this book, you'll get to know my art, which is a reflection of my inner world; and through creating this book, I'd know that my art will someday enter another person's life.

The best part of this experience, beyond the dance of colors and lines, is the fact that we can both let ourselves be vulnerable for a moment. These artworks are visual expressions of myself. Elements of unclothed skin are metaphors for my own weaknesses and fears, yet also the braveness and liberation I want to have by showing them out in the open, in all their rawness.

All the emotions or inspirations that might have surfaced during your viewing, are the same ones I've experienced at some point in my life. I hope you find comfort and resonation in this message: we may feel lonely, but we are never alone in our feelings.

Warm hugs,
Danni Shinya Luo

BLEEDING EDGES is a review and a preview.

The last art book Danni Shinya Luo published, **Soft Candy**, was more than 10 years ago. In between this time, she took a few years to grow a little human being, and then a couple more to struggle through creator's block. In 2020, she was introduced to a platform called Async.Art, which provides creative tools for Web3-ready artworks. It was the spark that reignited her passion for creating, breaking through the limitations of physical artworks, she now creates interactive cryptoart using tools from Async.Art.

Part of this book is looking back at Danni's earlier work, drawings and paintings on paper, echoing the idea of "bleeding edges" through watercolor blooms. The other part is looking ahead to the future, into the Web3 era, where digital ownership is possible for all; taking art lovers to the bleeding edge of art technology.

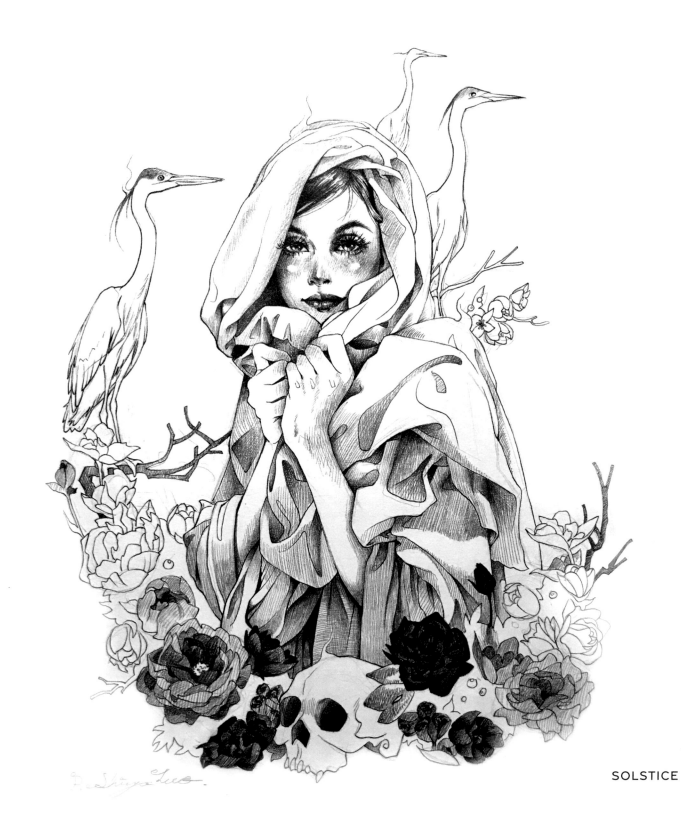

SOLSTICE

LINES AND SHADES

For me, the birth of an idea starts with lines. One can express a lot with only lines. Using the line's weight - how thick and thin it is; its length; its curves and angles; and the space in between. When a line is very short, it becomes a dot; when you line up many of them close together, they become a surface. And sometimes those are all I need to create a visual moment or convey a feeling.

There are other times where I want to say more in a drawing, that's when I add in the marker shadings. My favorite is to pair shades of warm grey with crimson color pencil, put them together on smooth marker paper. This combination gives the faces a lively, soft look; which creates that feeling of vulnerability.

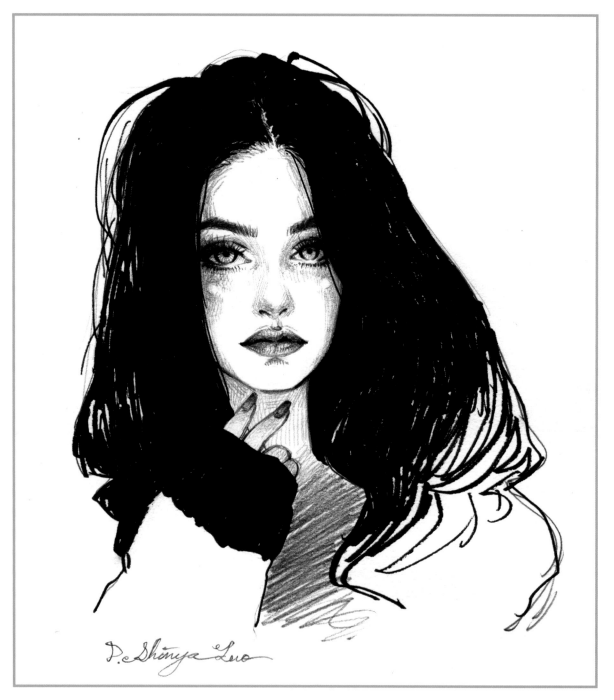

IN YOUR EYES

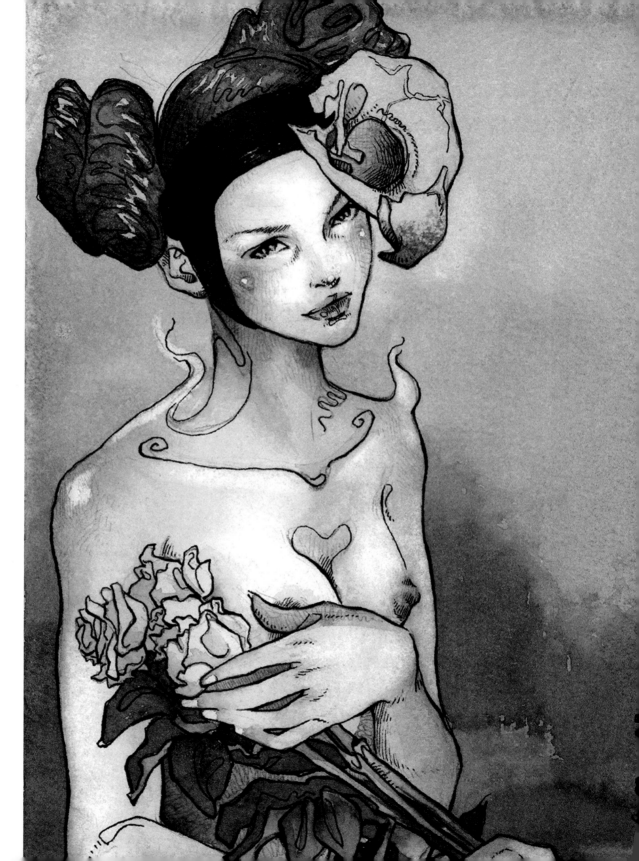

LOVER

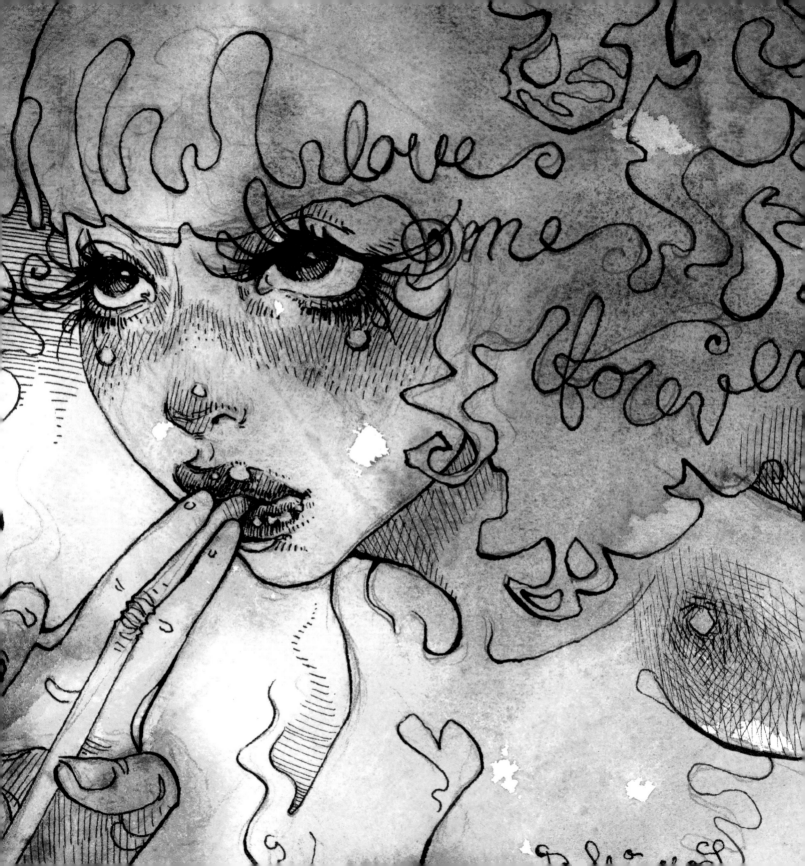

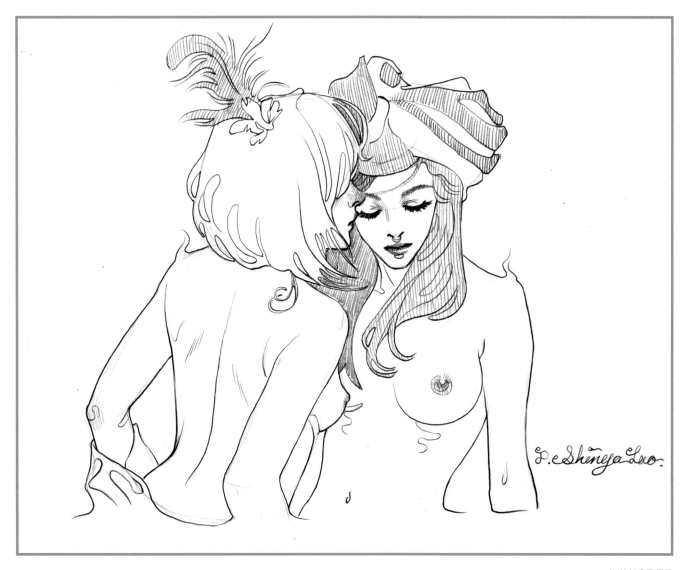

WHISPER

Goodbye, sleep
 Neon lights

The world glows brighter
 After midnight

Neurons firing
 Us craving

Lips touching
 Hearts breaking

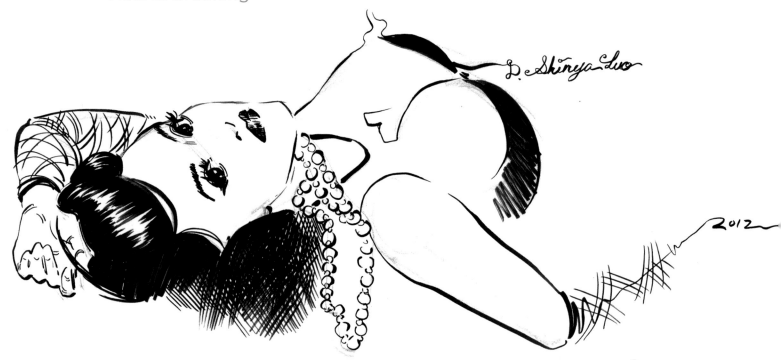

LEEN

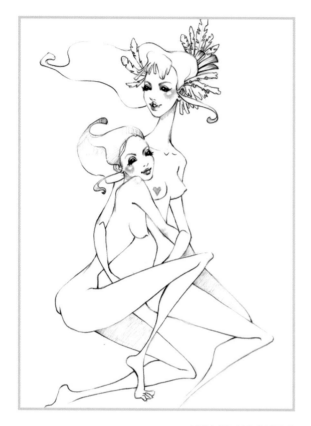

HOLIDAY GIRLS

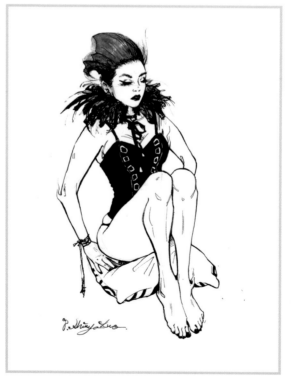

BLACK FEATHERS

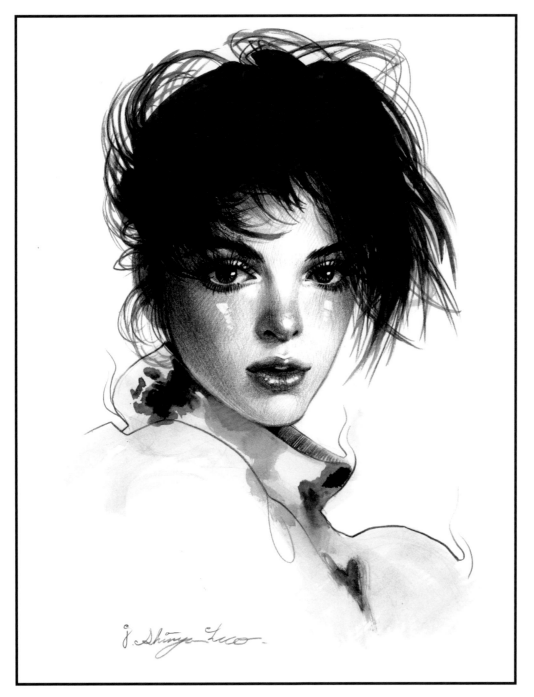

GAZE

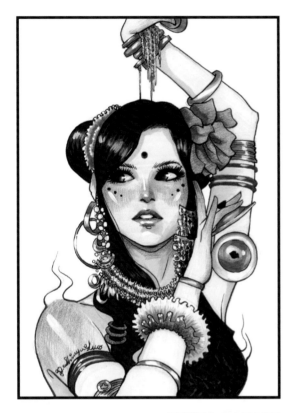

TRIBAL DANCER

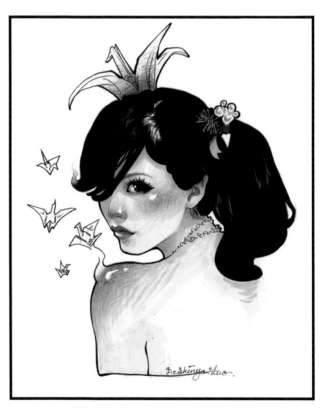

ORIGAMI MIA

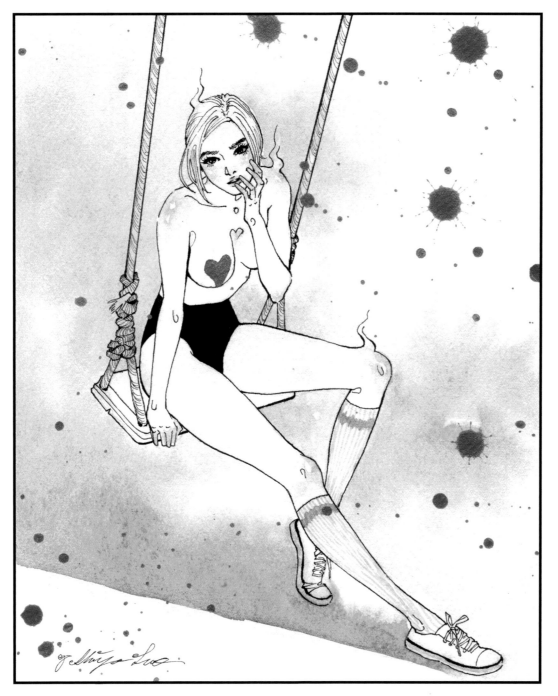

SWEET SUMMER

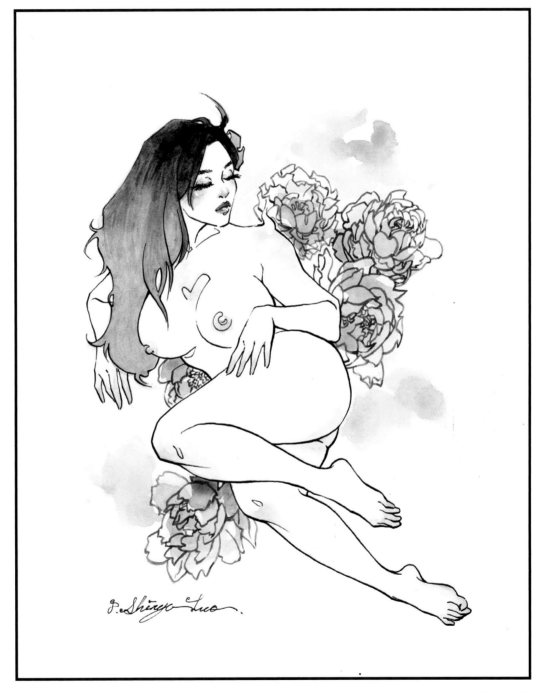

PEONIES

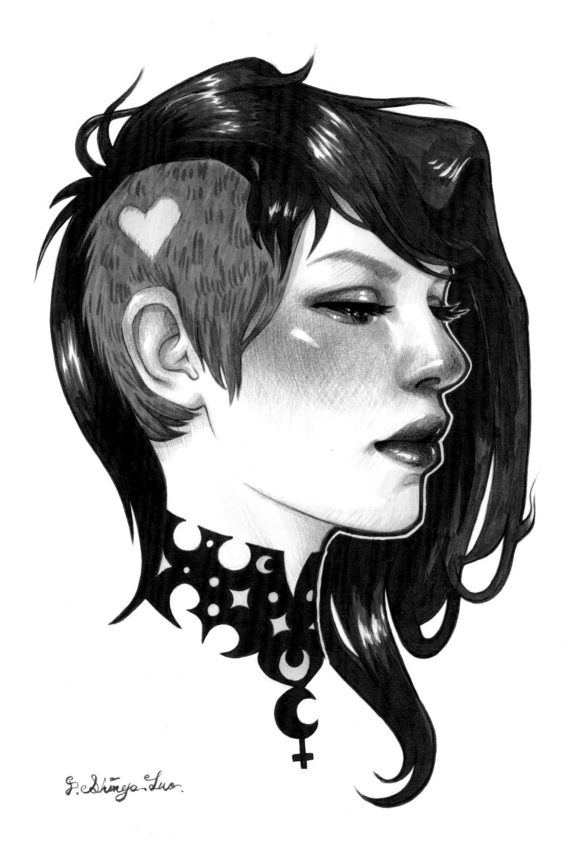

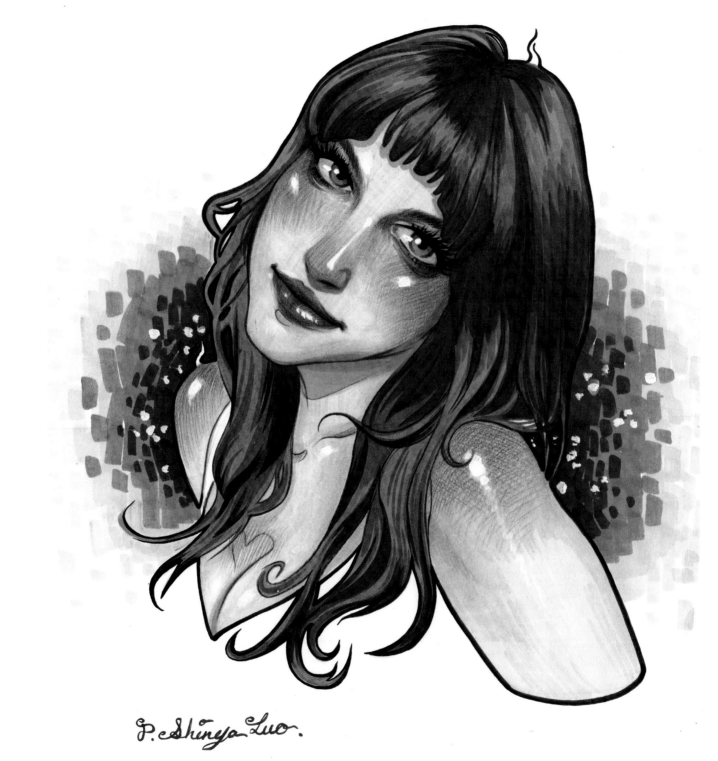

P. Shinya Luo.

I threw myself off
the stairs

Hoping you will be
there to catch me

Waking up in the
hospital

The nurse said
"You can go home

I'll call you an Uber
like last time"

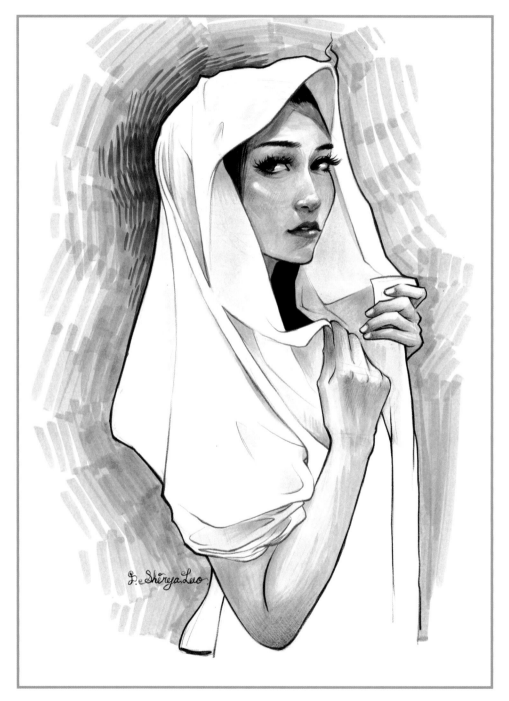

YUKI

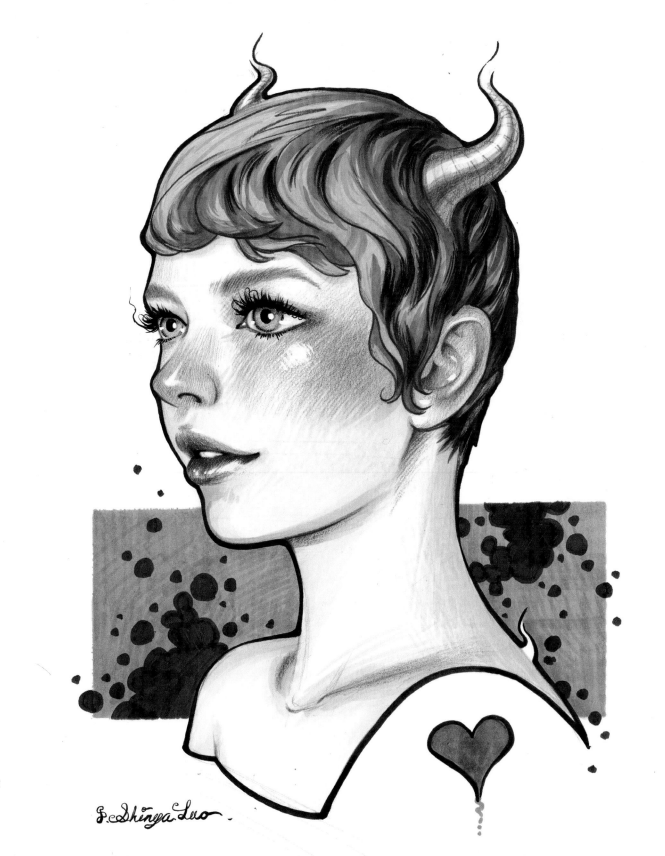

LUCIFER

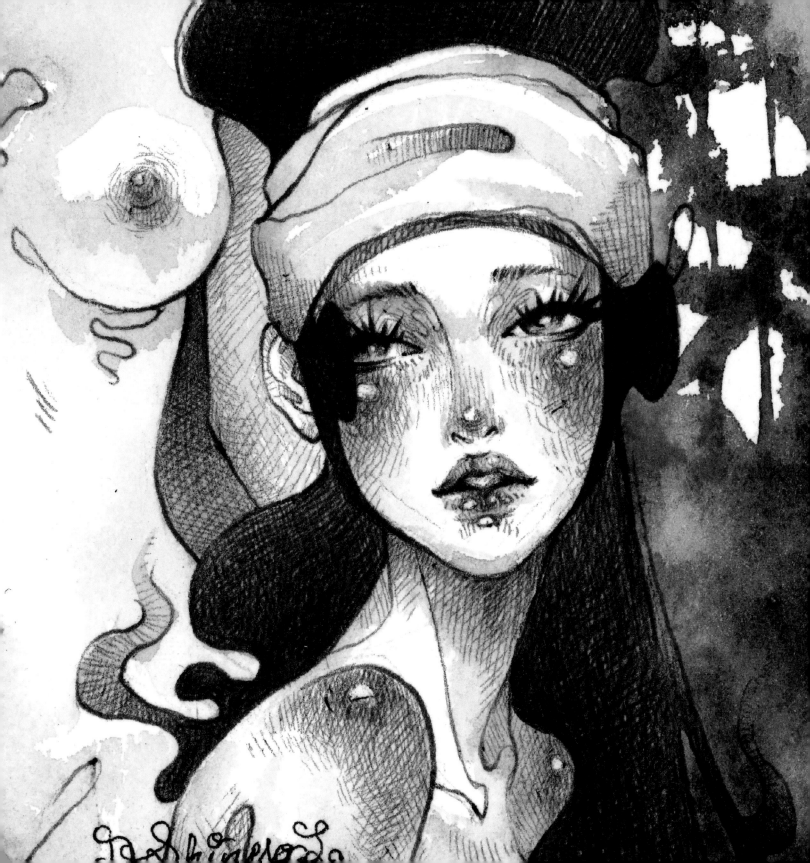

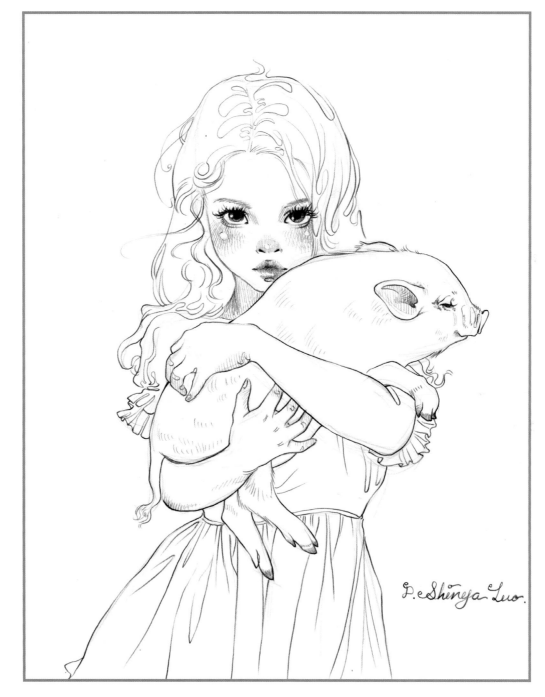

FRIENDS

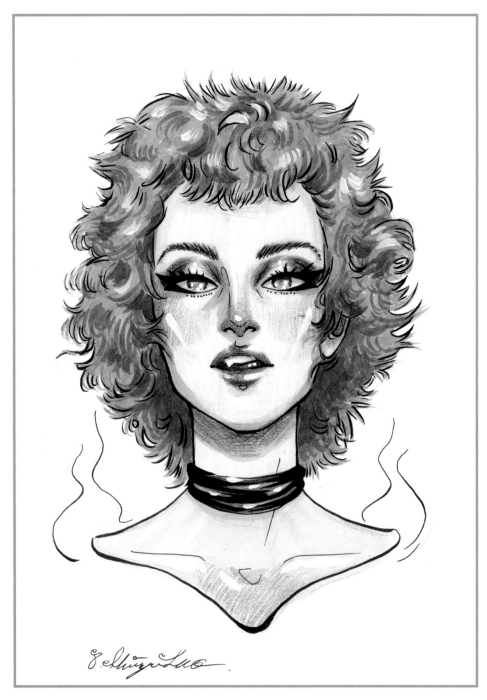

BLOOD SUCKER

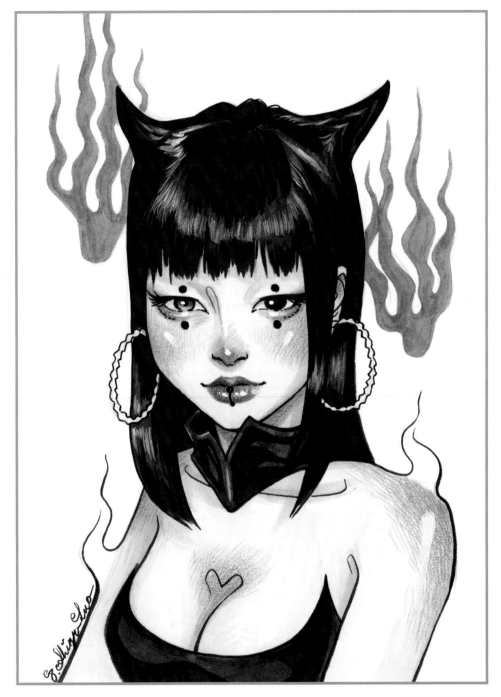

BLACK HORN

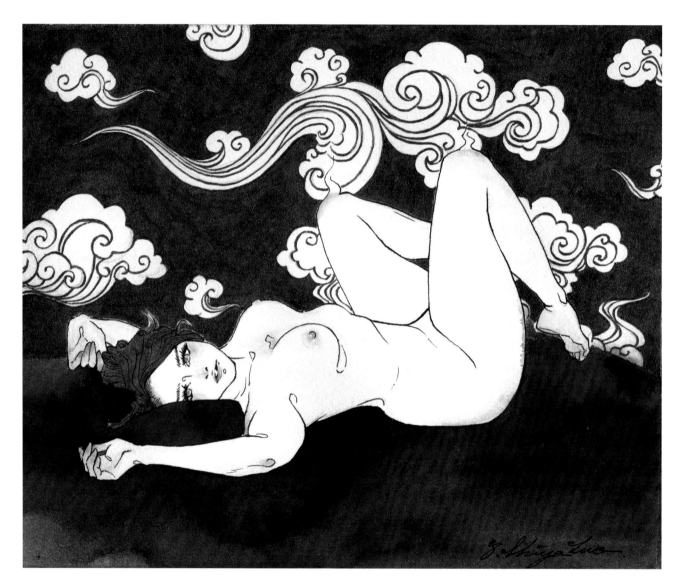

DREAMS FROM A NAP

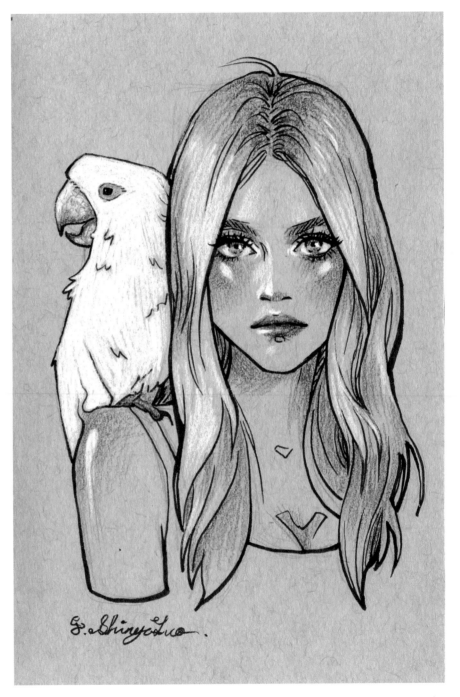

FEATHERS

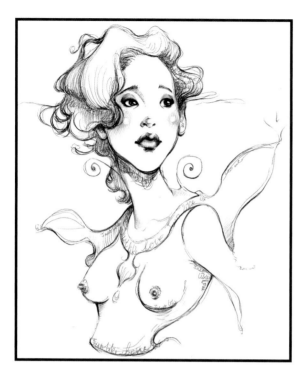

FAIRY BUST

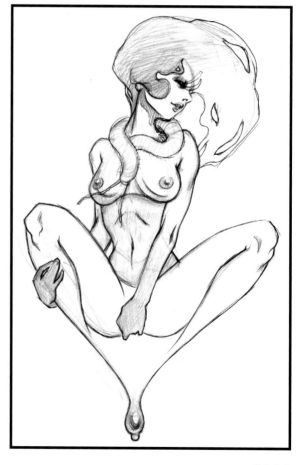

EROS

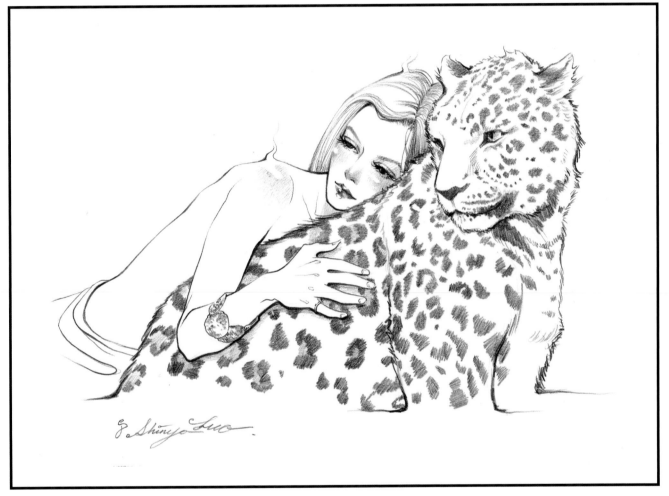

TO HOLD

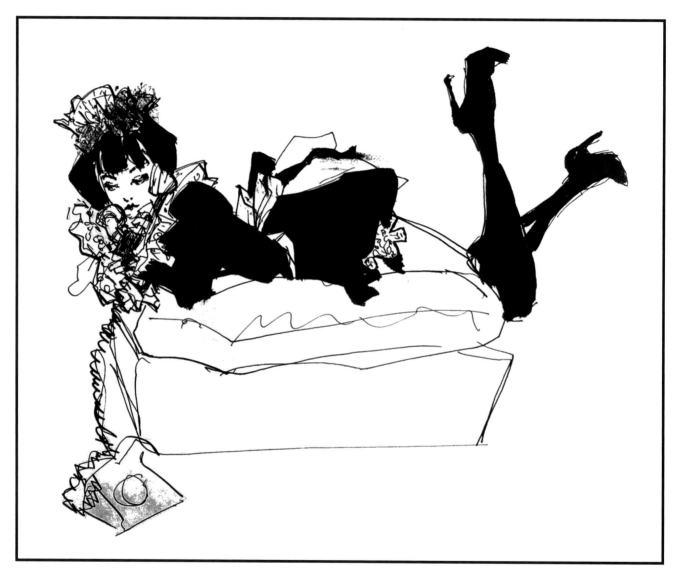

FRIDAY AFTERNOON

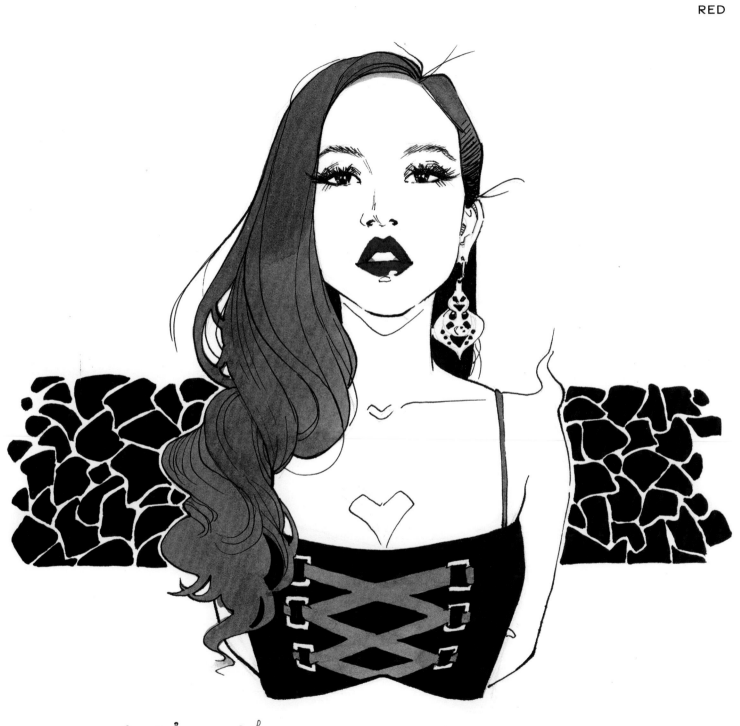

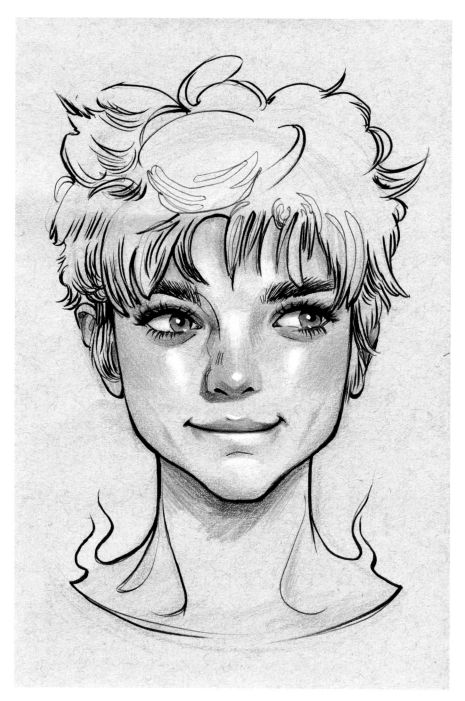

COLOR PENCIL STUDY

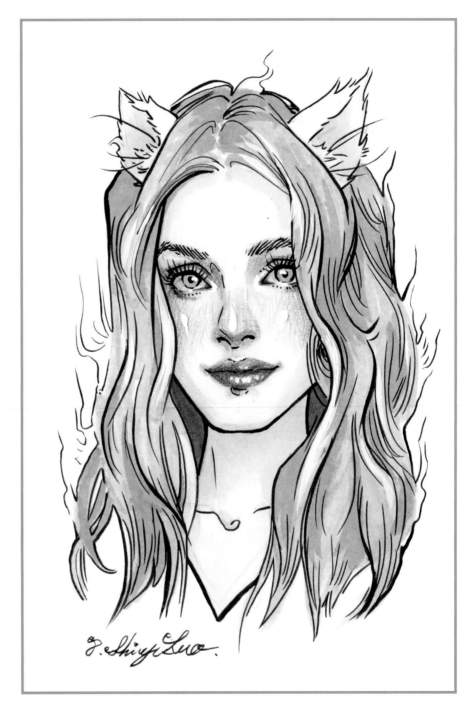

PURR

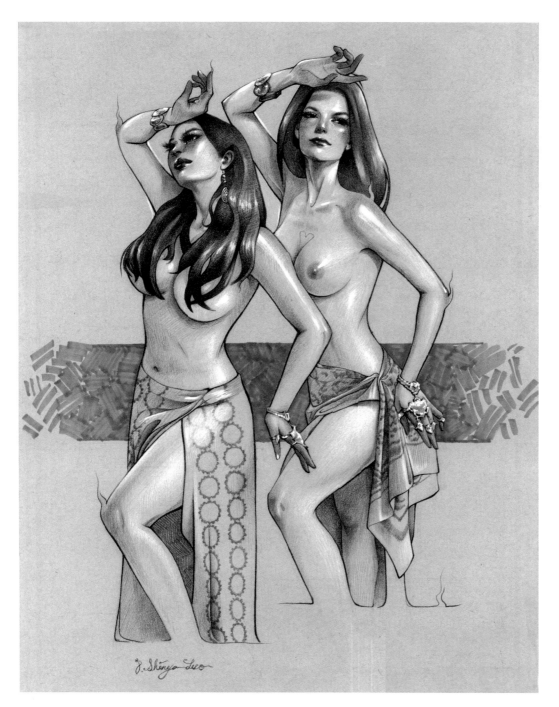

DANCERS

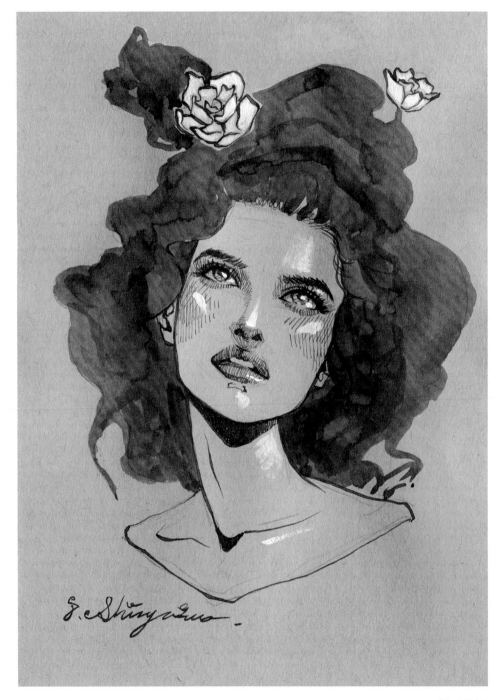

GLORIA

BRUSHES ON PAPER

Once the idea is flushed out. I will pick out the ones that make sense to be turned into paintings. It really depends on the mood of the piece. Some feel complete as a drawing, others require color and texture to tell the whole story.

In the earlier days, I did all of my paintings in watercolor, with ink lines on top, and they are done on cold press watercolor paper. I love the delicate, spontaneous look of watercolor's bleeding edges but these paintings are fragile, since watercolor is not the most permanent medium.

After I got more comfortable with the medium, I started exploring other more permanent mediums on top of it. Through trial and error, I found a perfect combination of sealants that will water - proof the watercolor without disturbing its color and texture. Once I seal the watercolor and ink lines, it allows me to add depth and/or refine any part of the painting using acrylic or even oil.

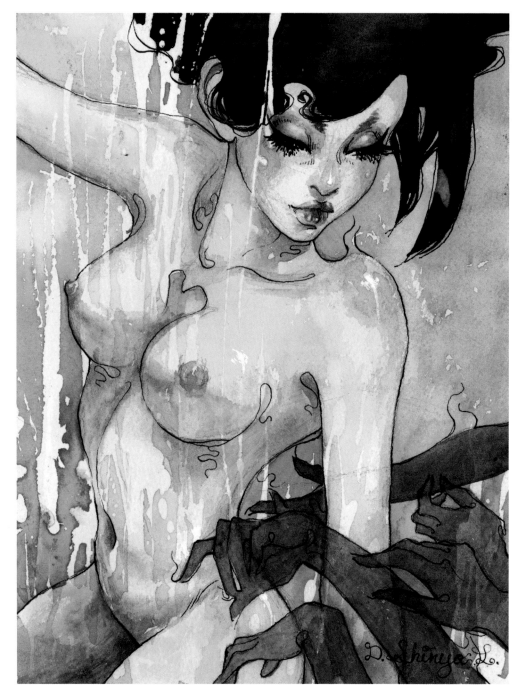

REACH

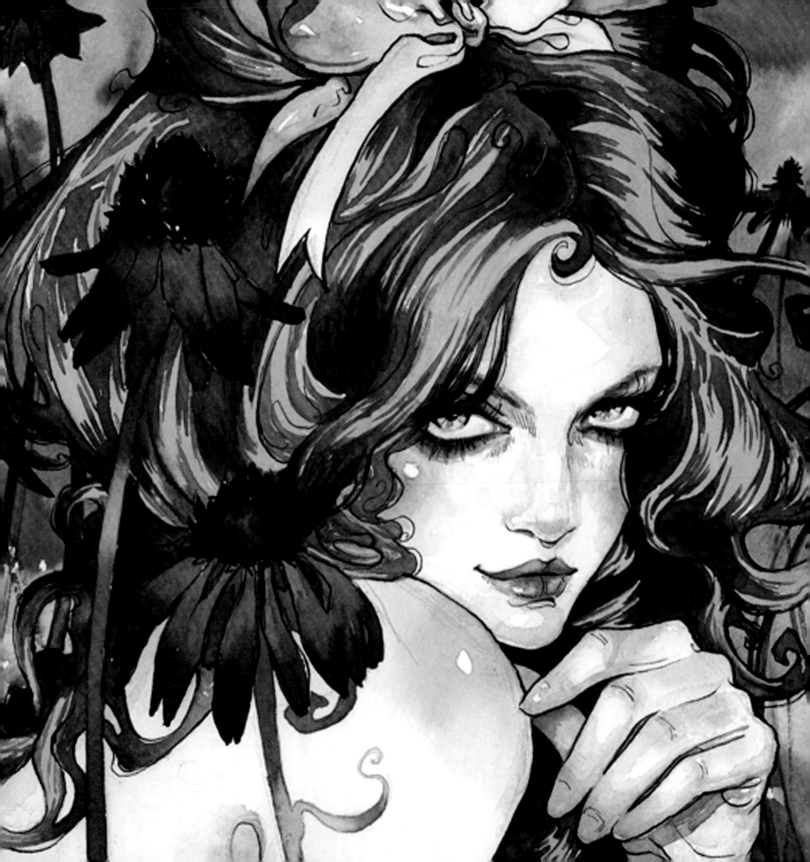

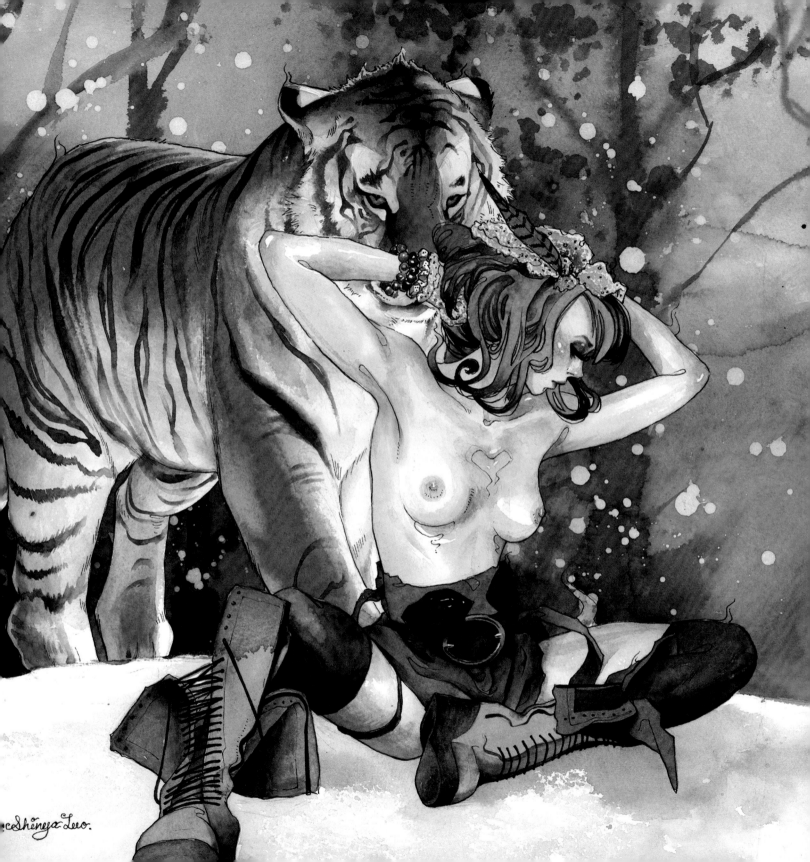

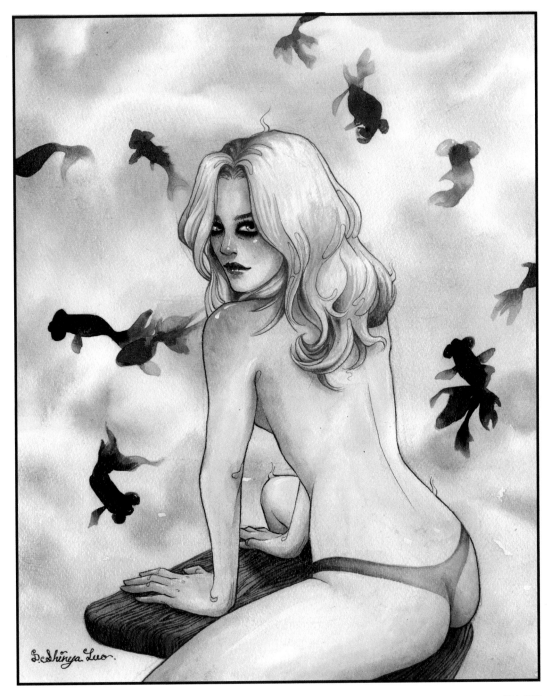

BARE

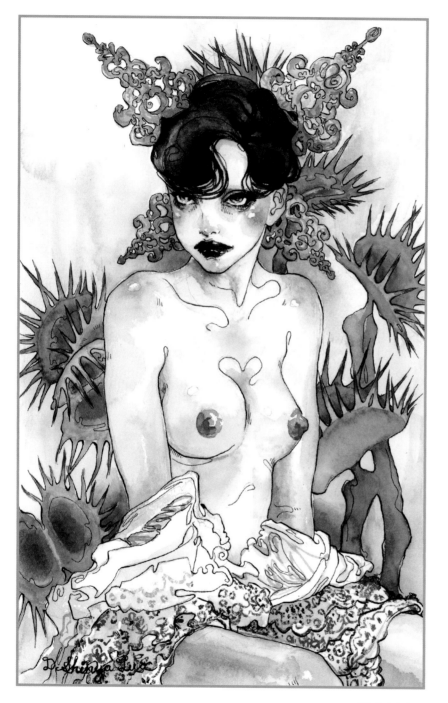

the ending will
be bittersweet

but you already
know

a tangled mess,
or make it neat

nothing is yours
to keep

BLOSSOM

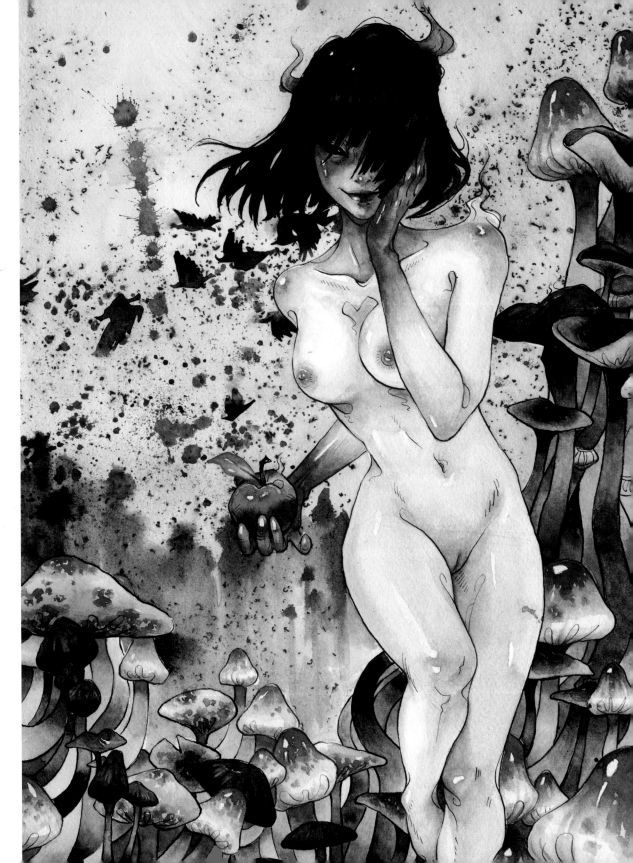

DESIRE

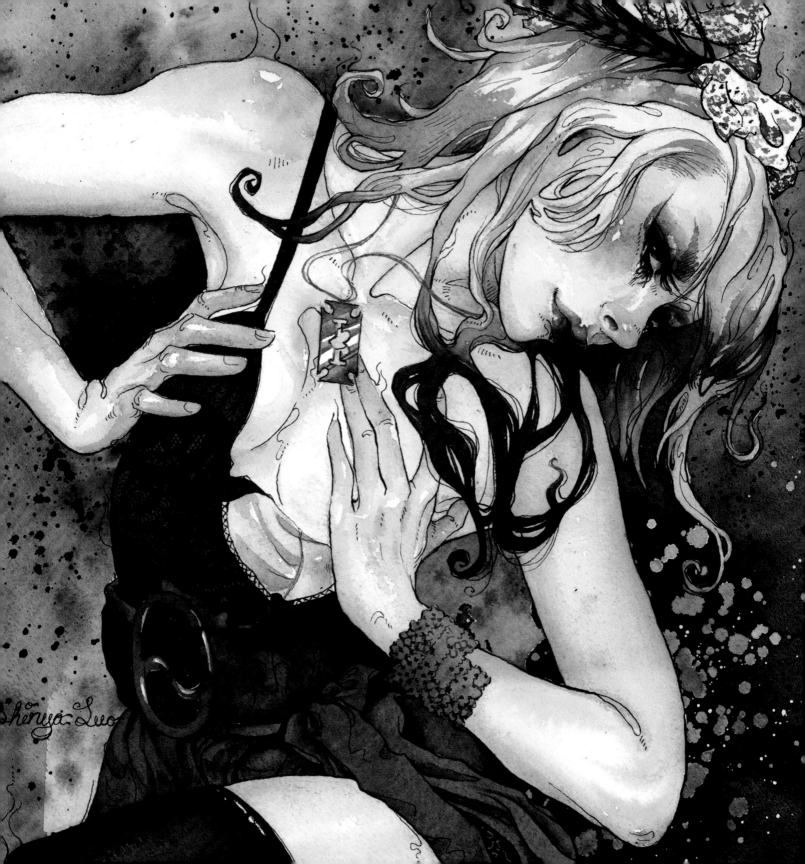

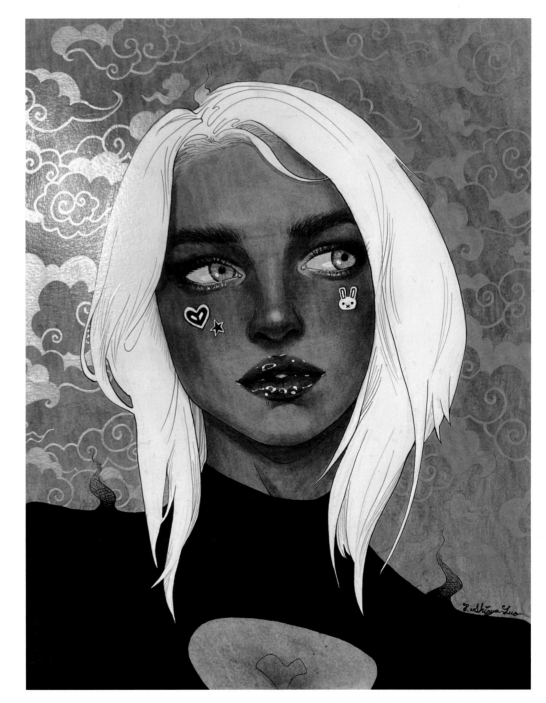

CURIOUS ABOUT TOMORROW

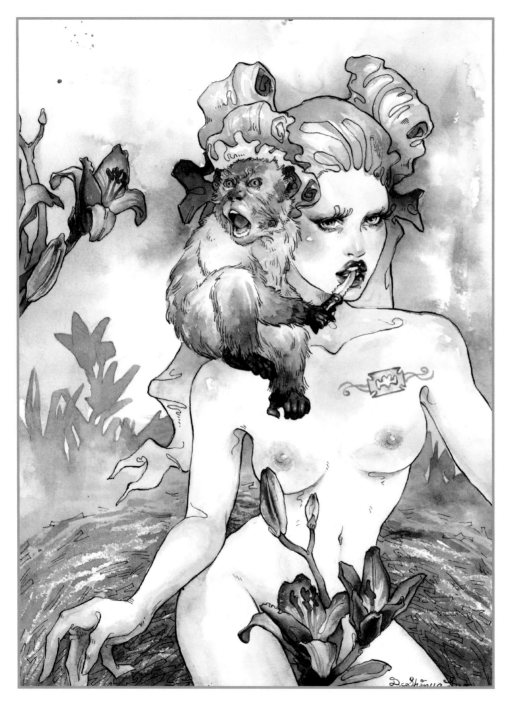

GUARDIAN'S DILEMA

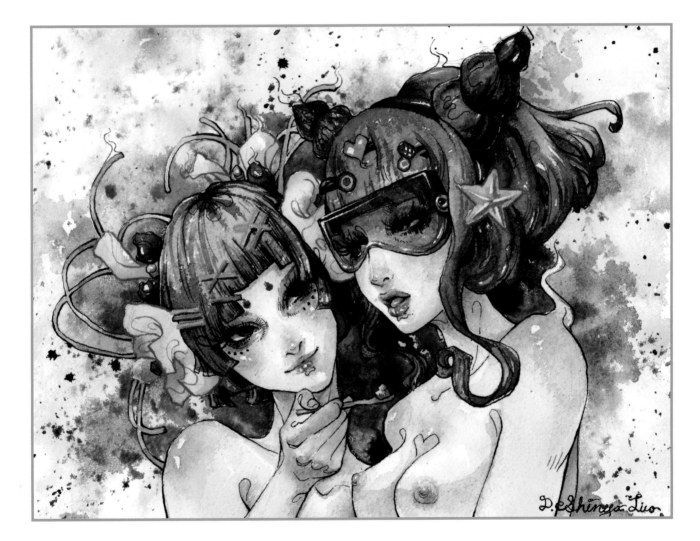

DEATH BY SUGAR

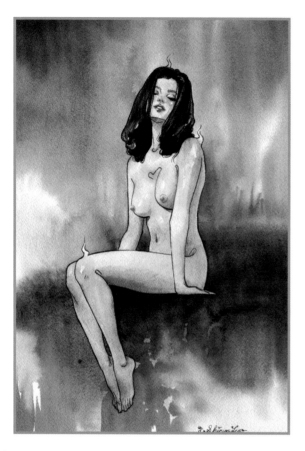

DRIZZLING MORNING
BY THE CREEK

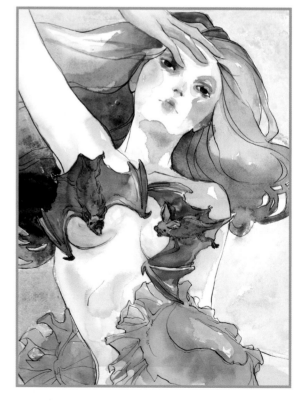

HABITAT

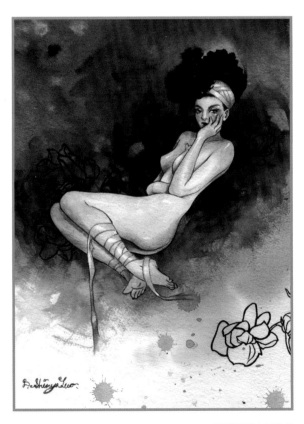

INTERLUDE

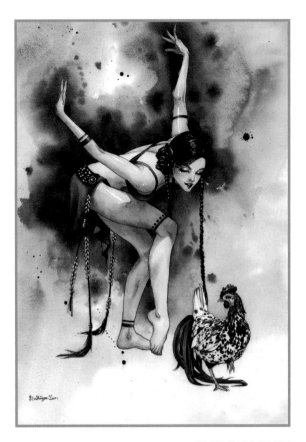

THE PHOENIX

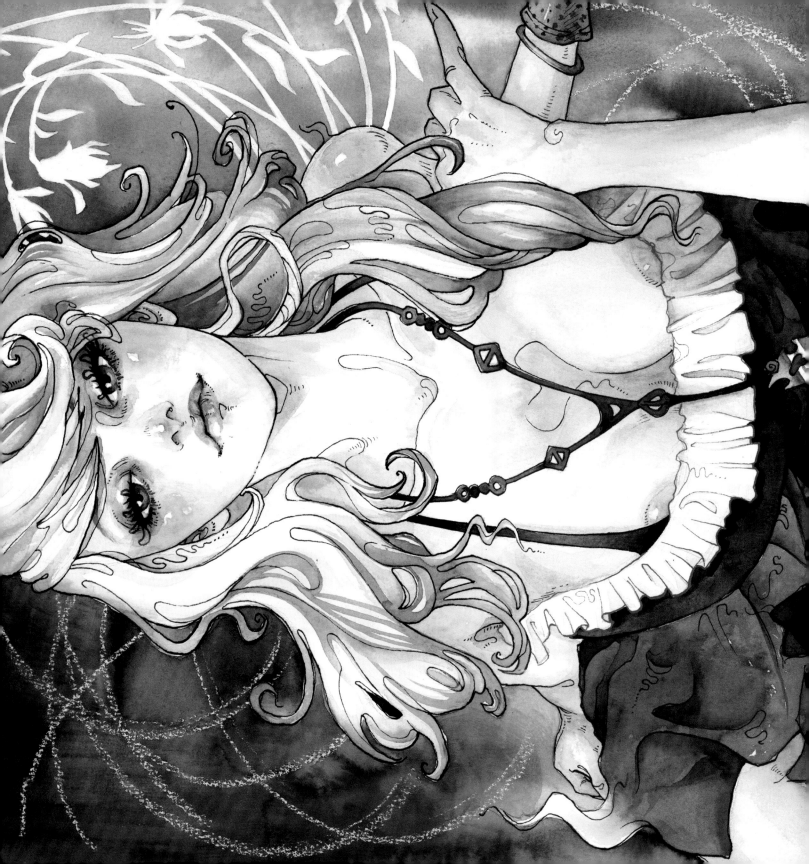

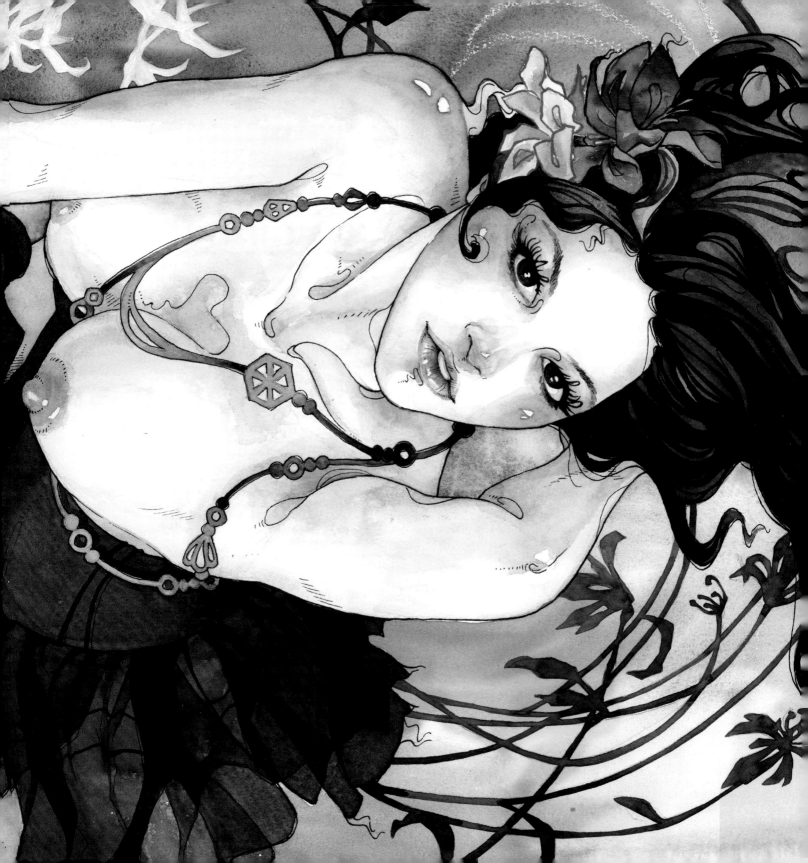

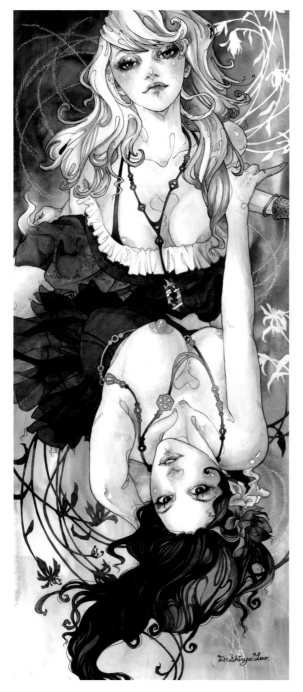

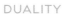

DUALITY

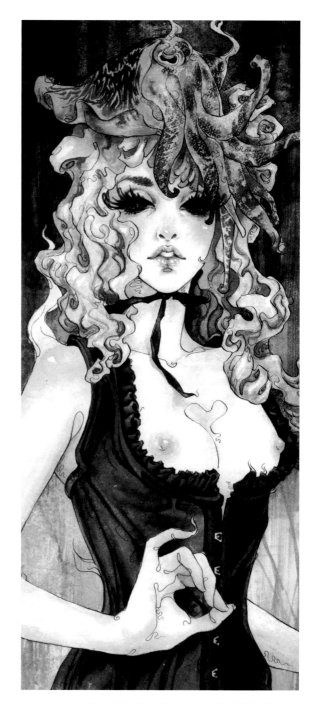

INSECURITY AS A CUTTLEFISH

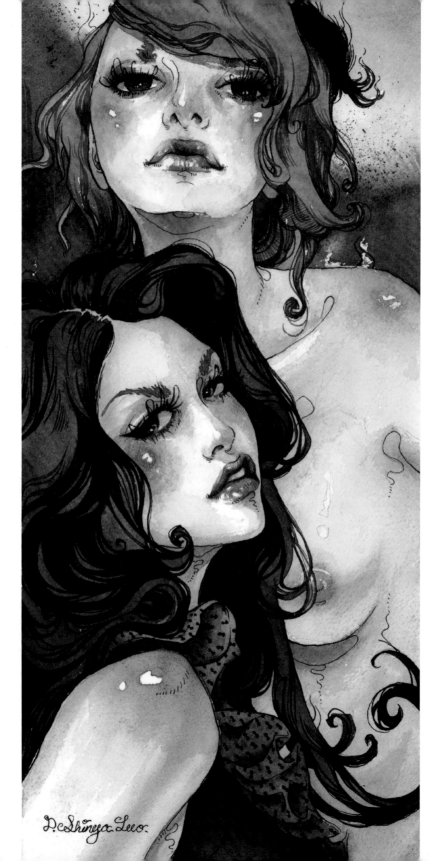

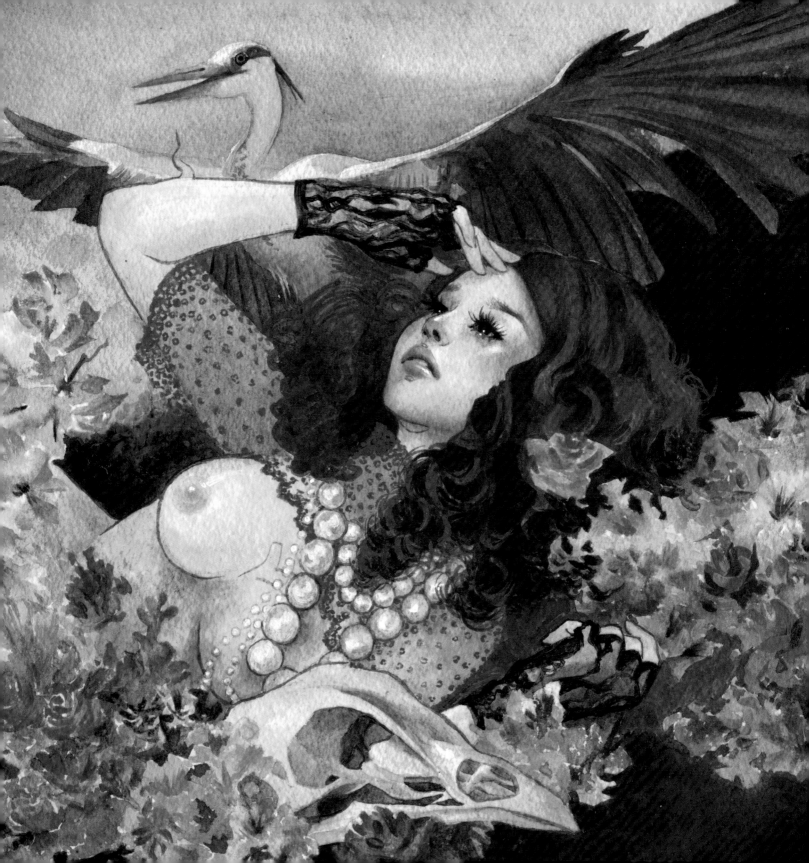

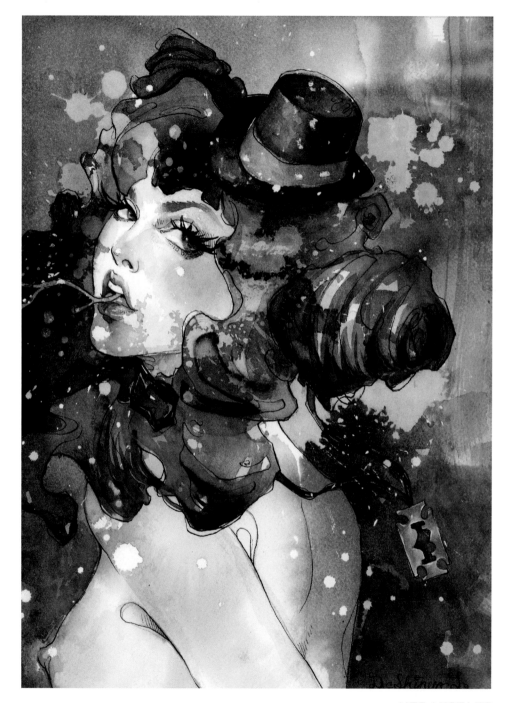

HER MISTAKE

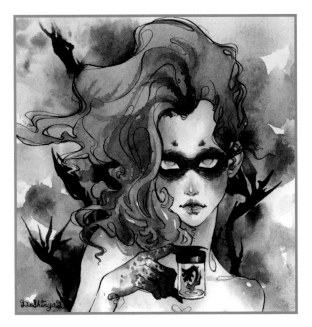

SOUL COLLECTOR

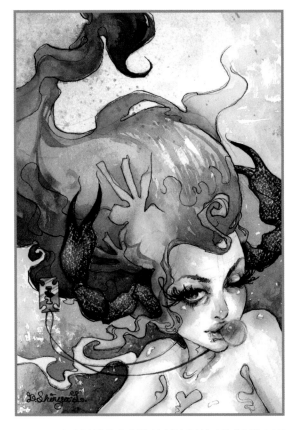

WHAT DO YOU KNOW ABOUT ME

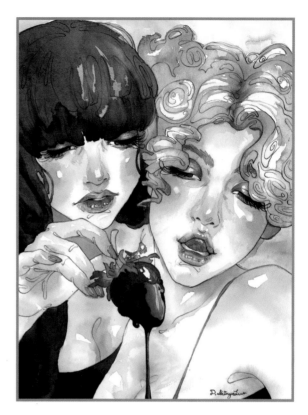

THE TEMPTATION OF EVE

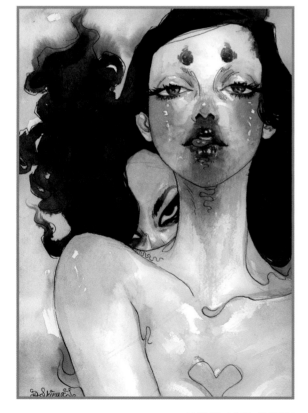

HIDE AND SEEK

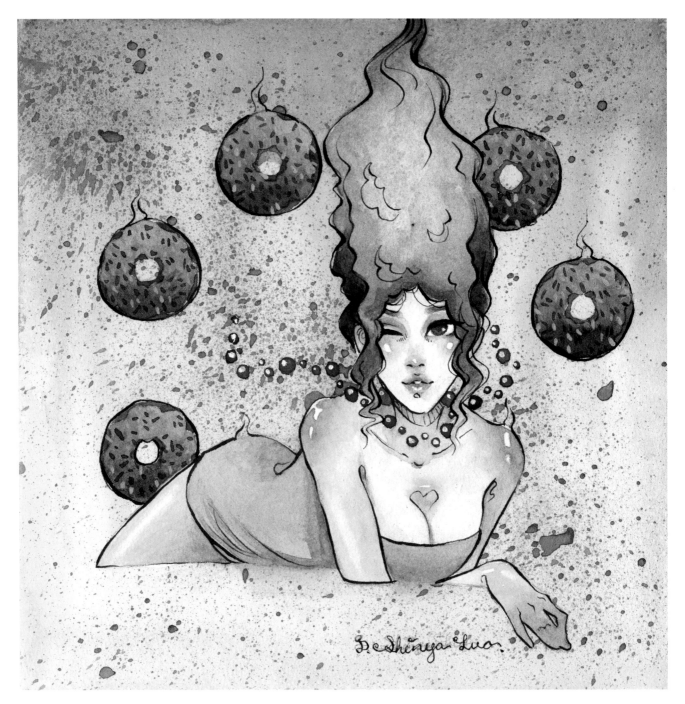

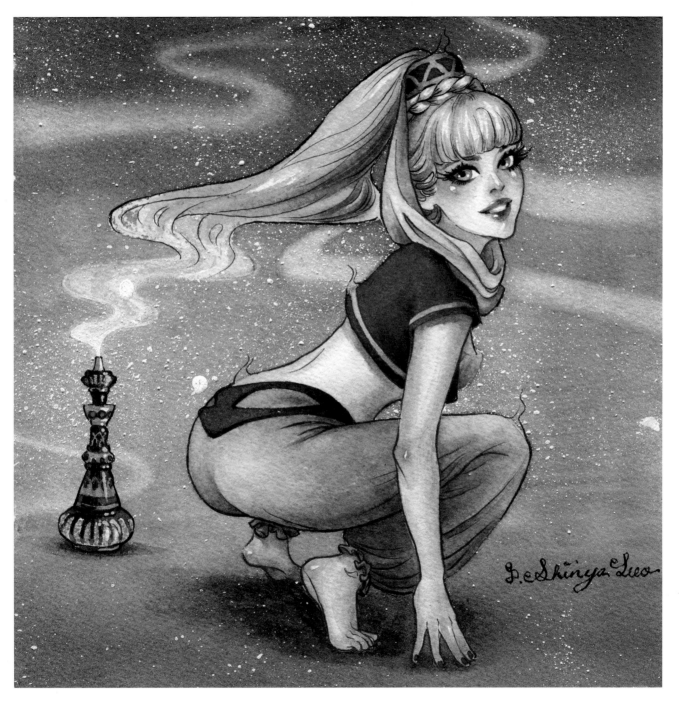

AT YOUR SERVICE

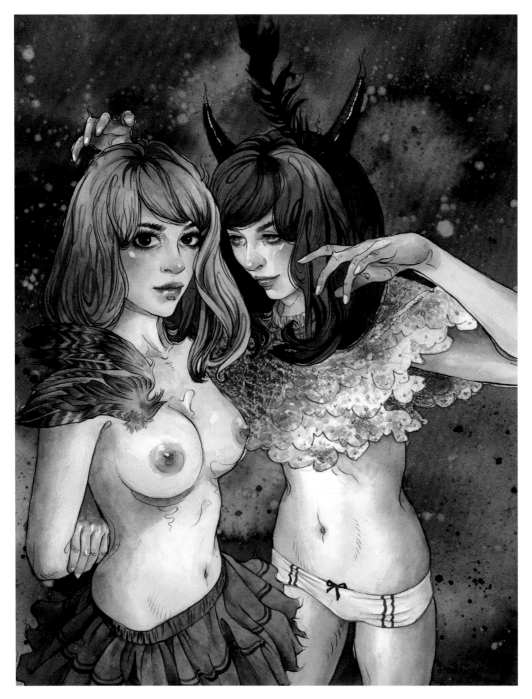

PLAY NICE

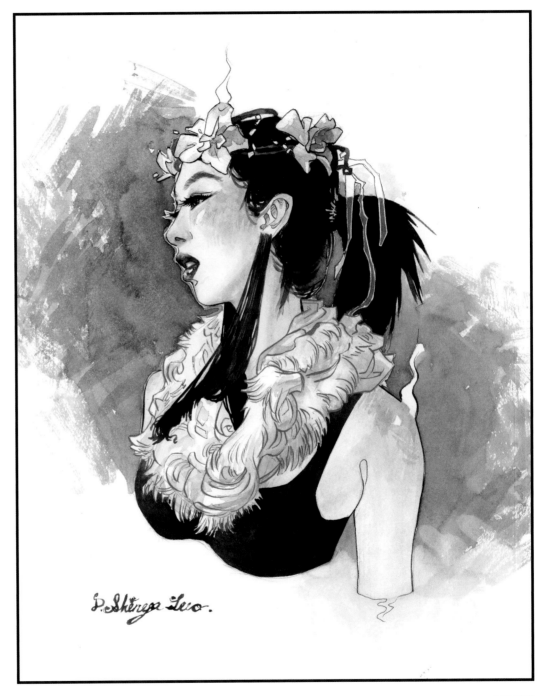

MUSE

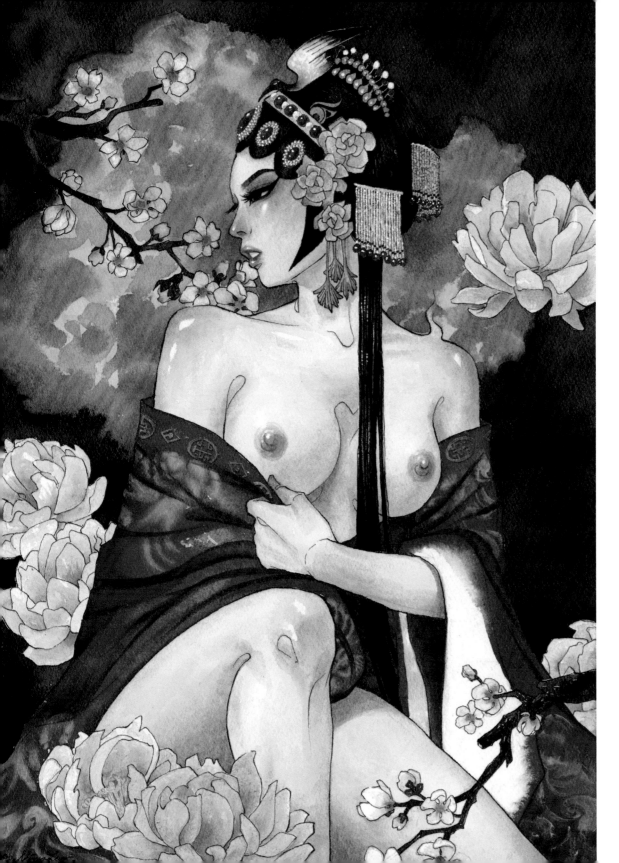

NEON LOTUS

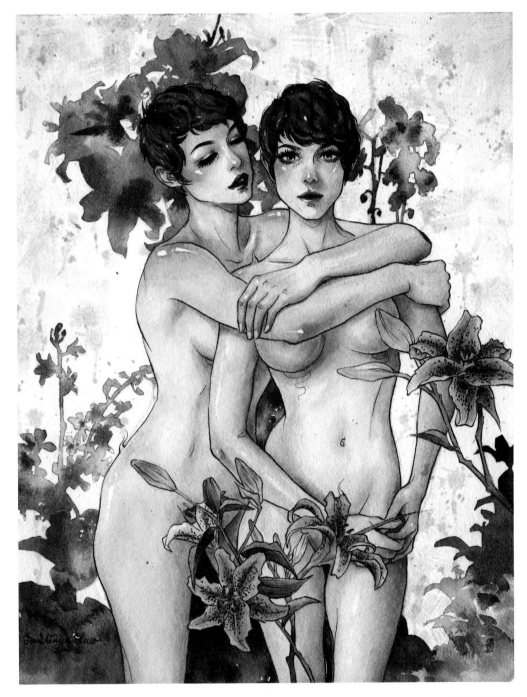

COURAGE

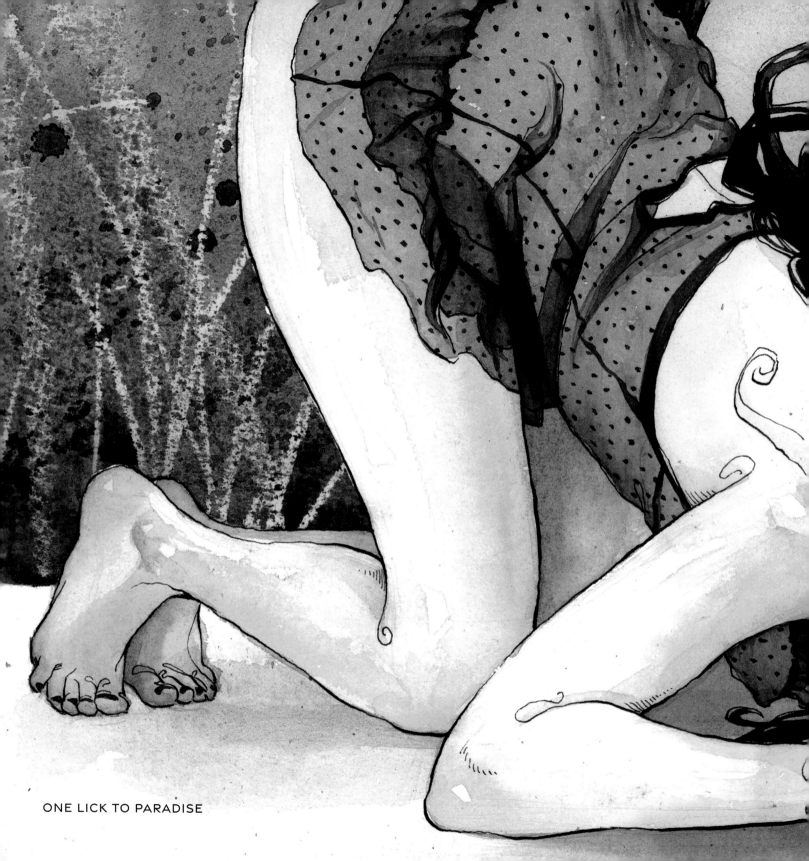

ONE LICK TO PARADISE

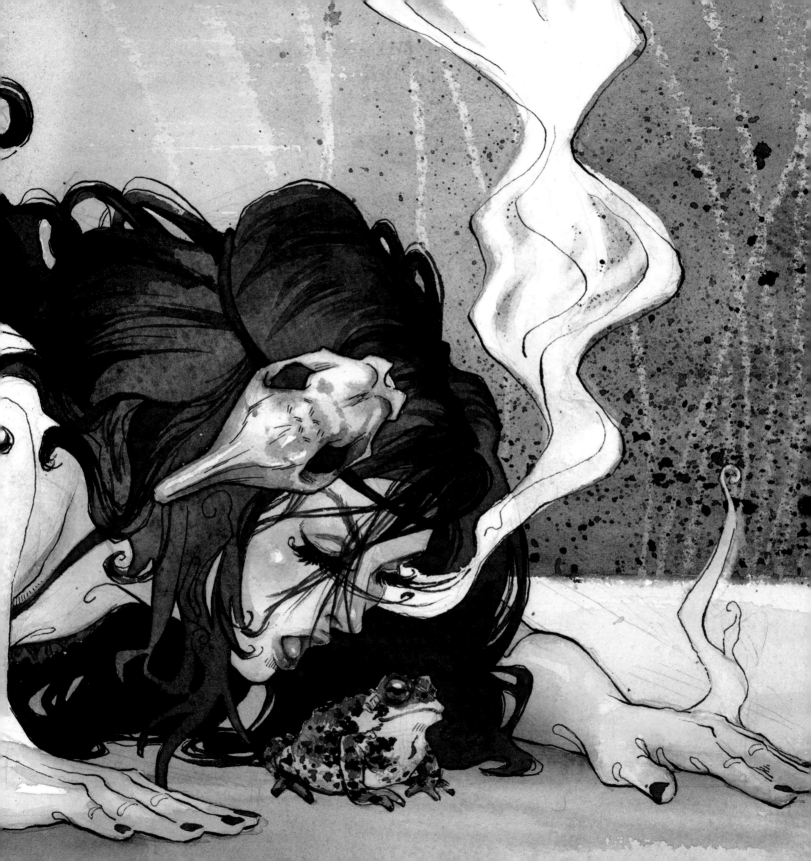

growing up without
realizing

accumulating memories

counting the faces lying
next to me

they keep changing

running out of storage
space

which one is the
final stop

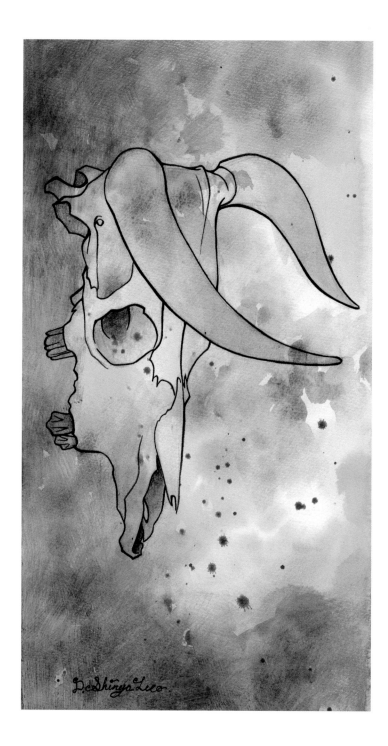

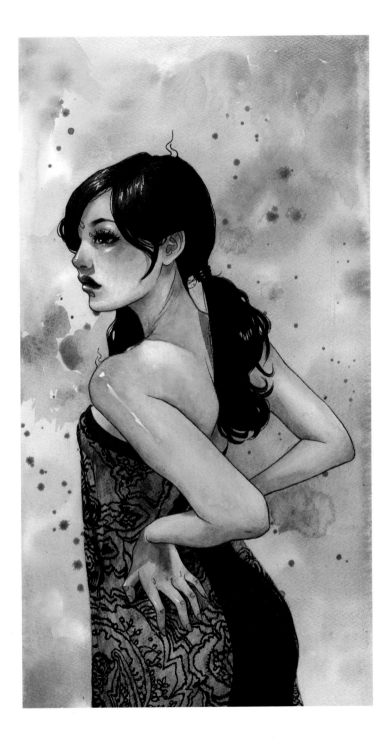

PINE
triptych

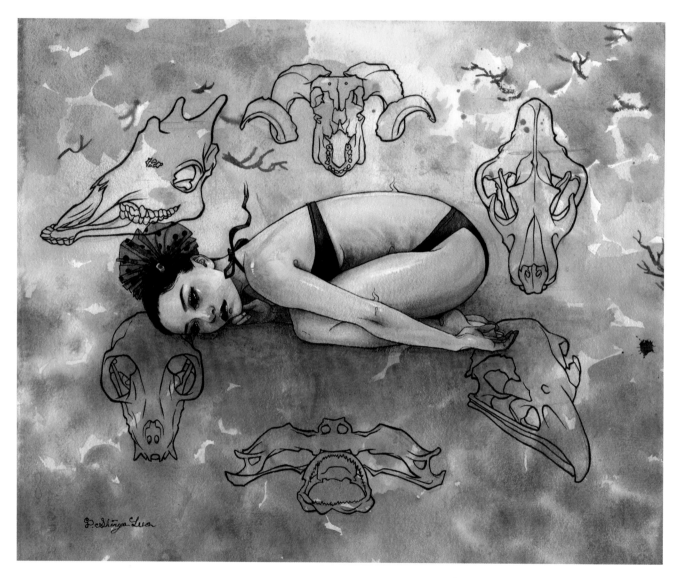

CONNECTED

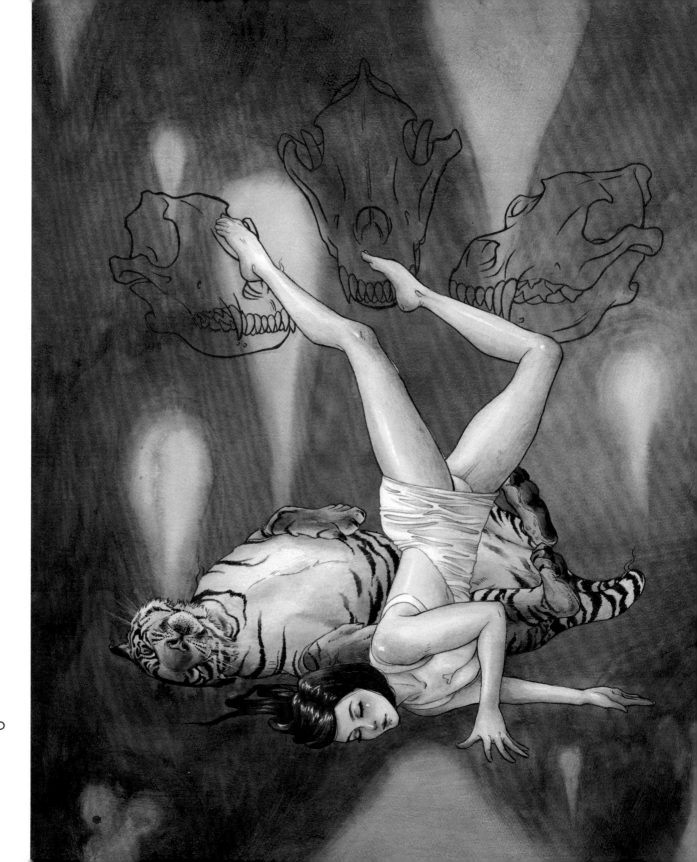

PLAY DEAD

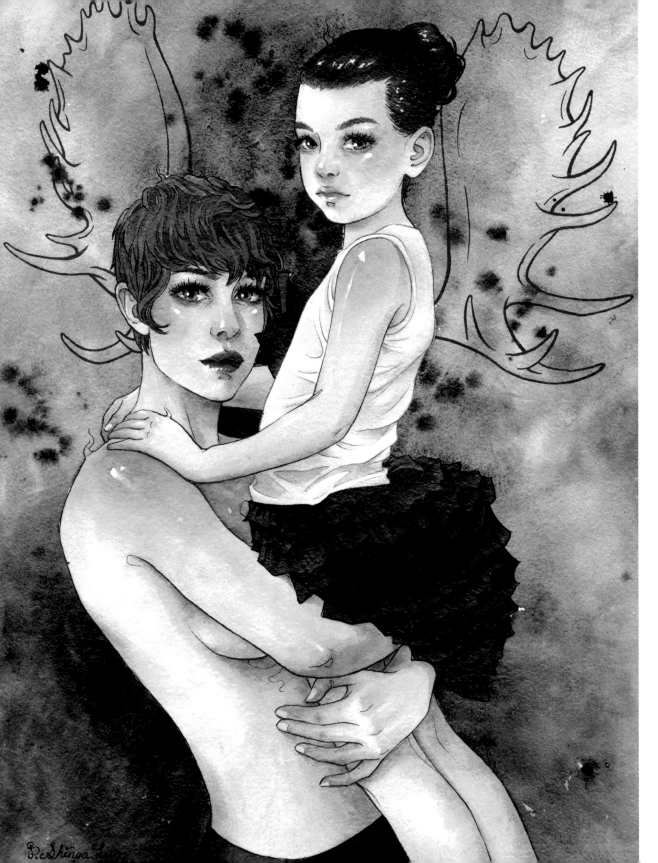

POSSESION

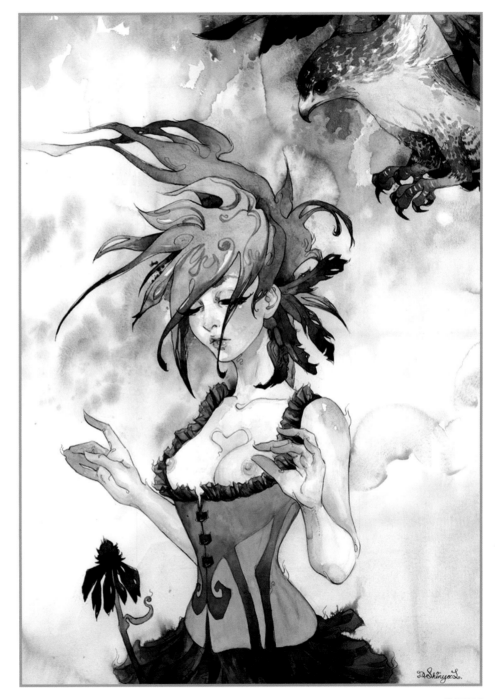

PREY

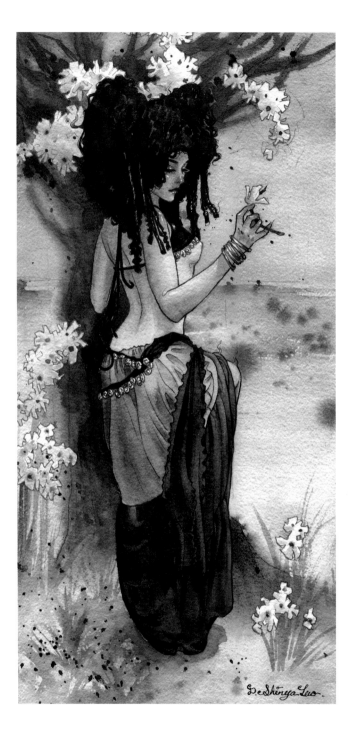
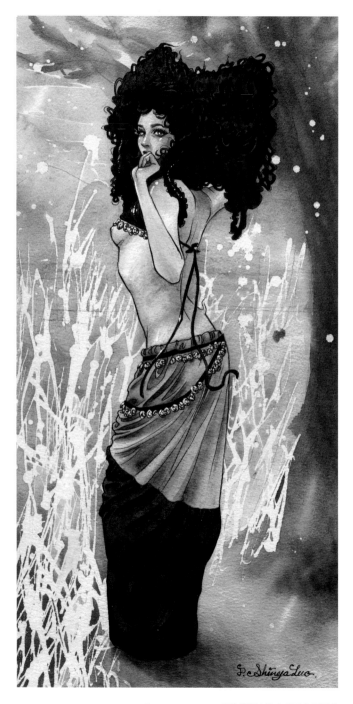

SPRING LINGERS
diptych

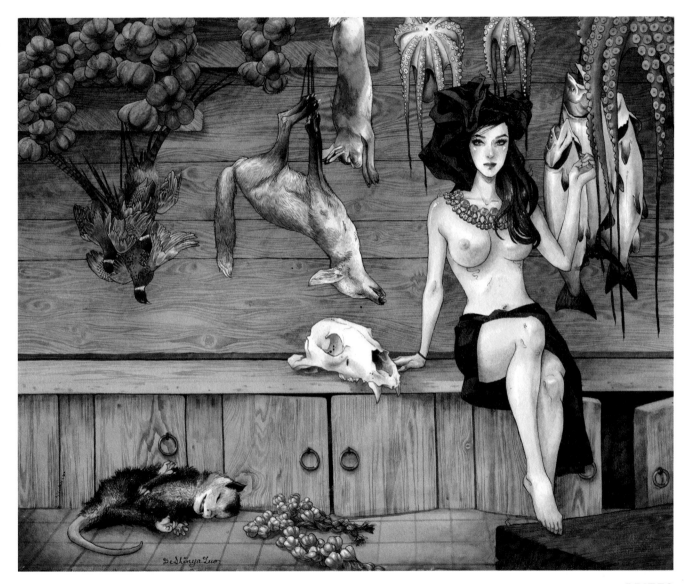

PRIZES

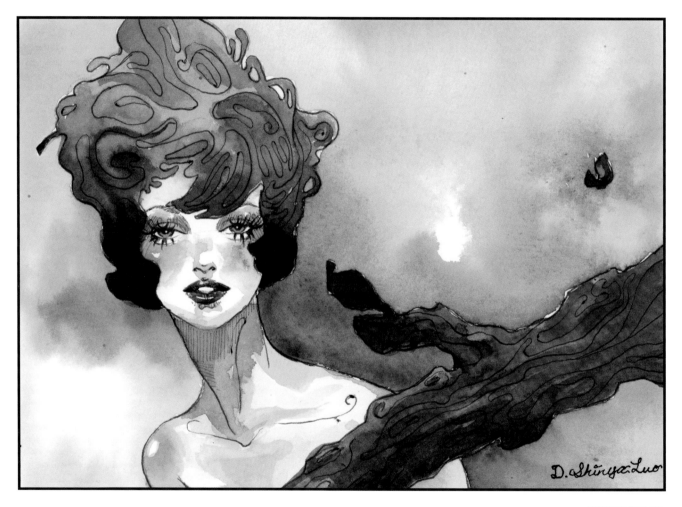

ZINFANDEL

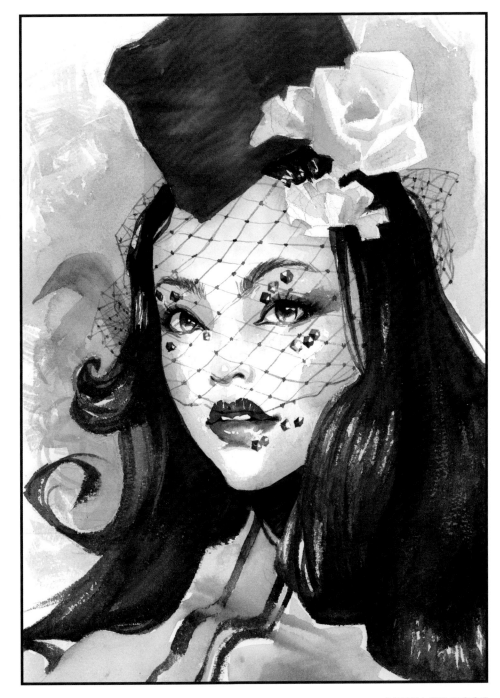

VINTAGE ROSE

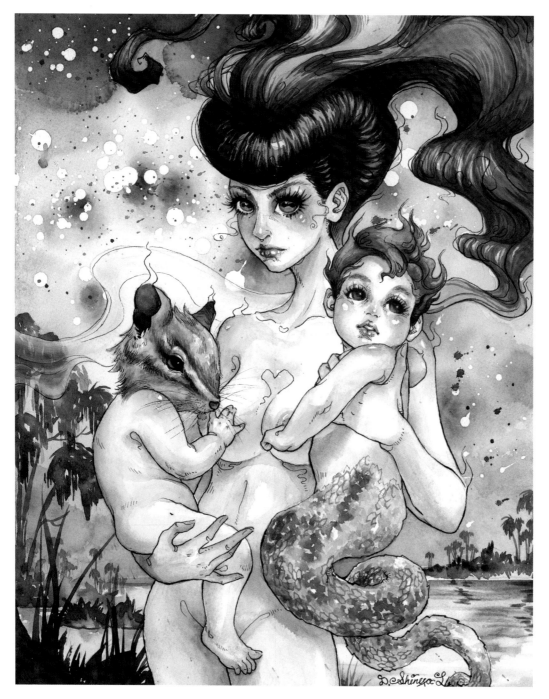

TAROT STAR

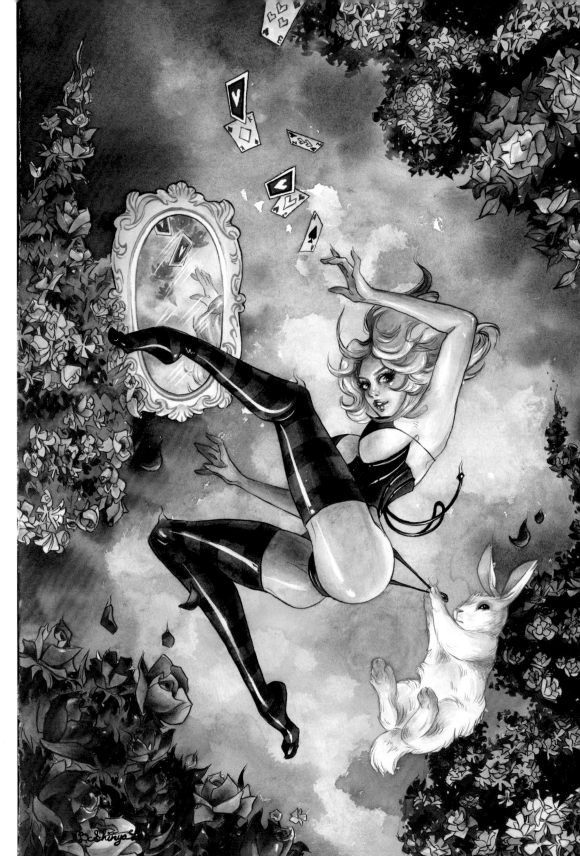

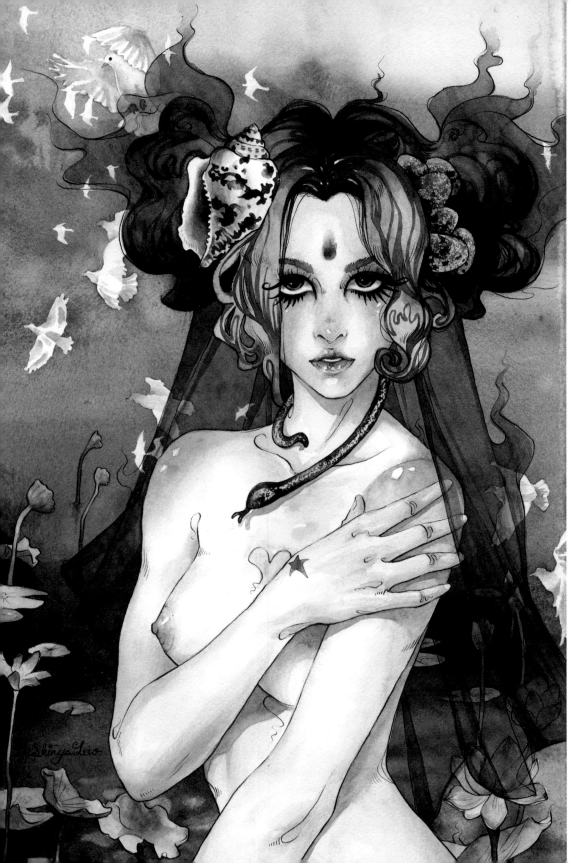

THE STAR

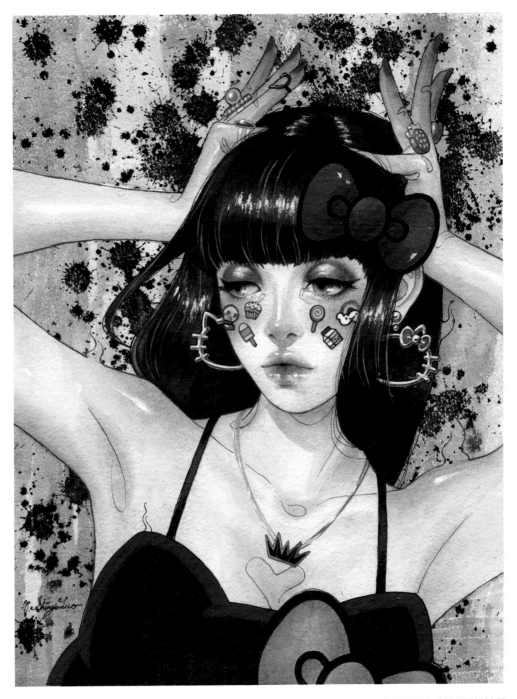

THE QUEEN OF KAWAII
[cover feature]

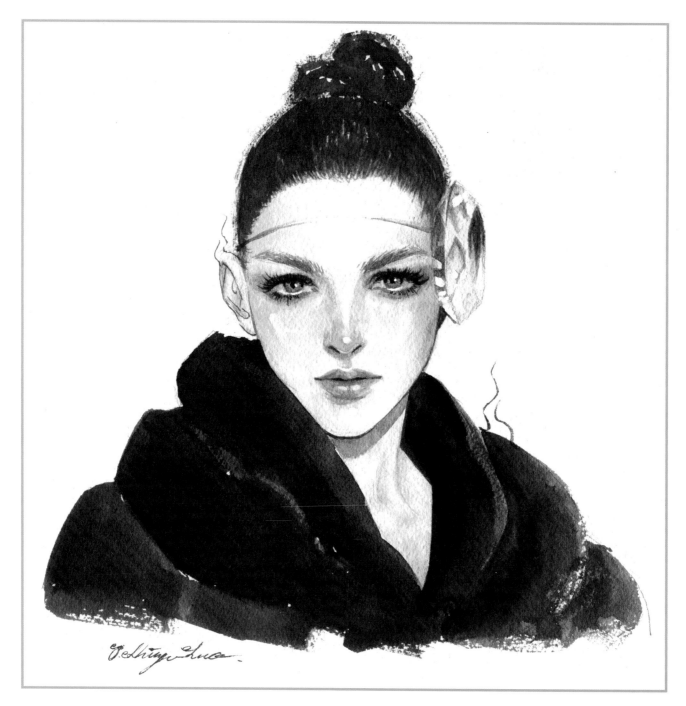

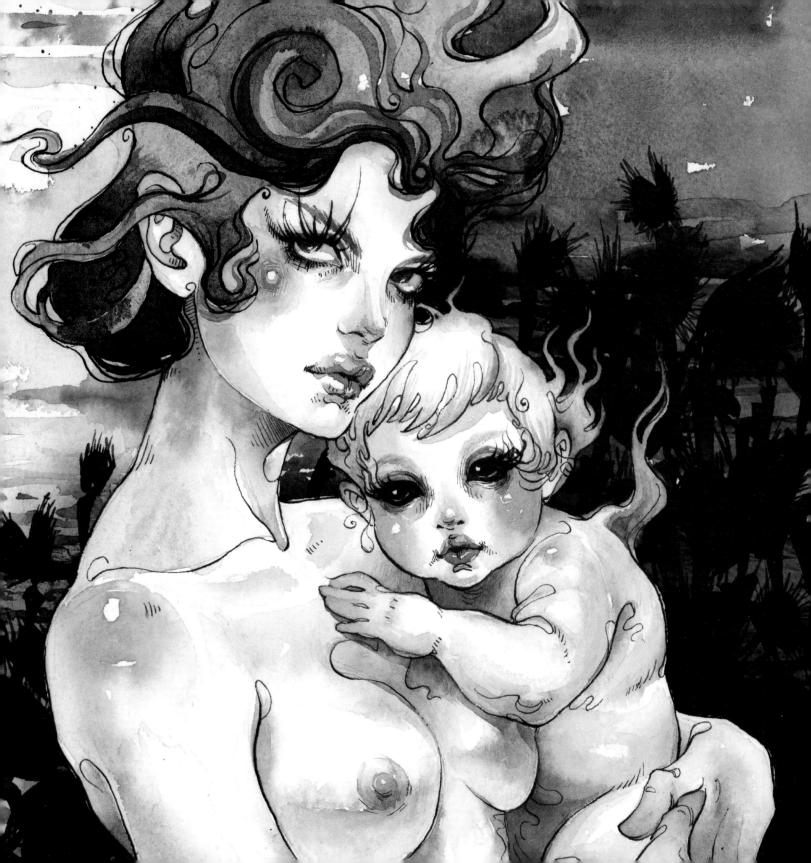

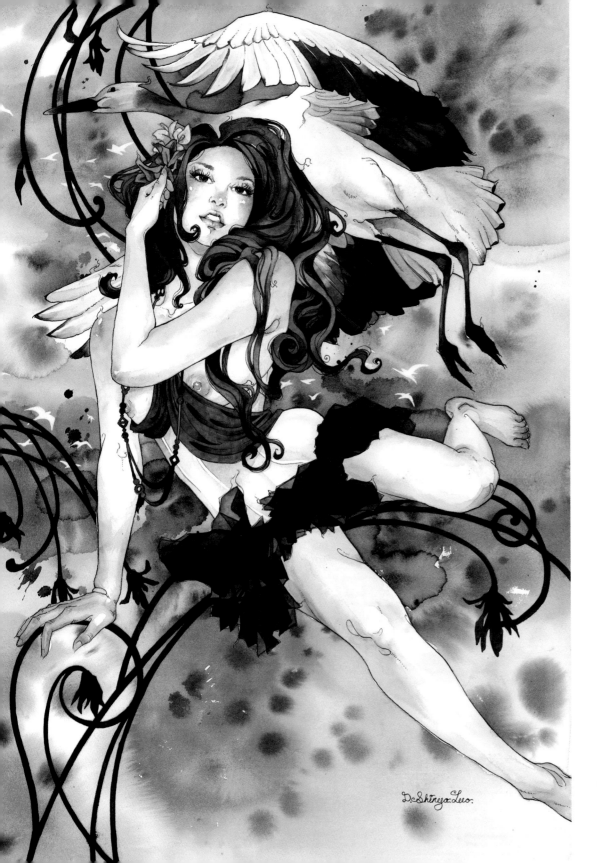

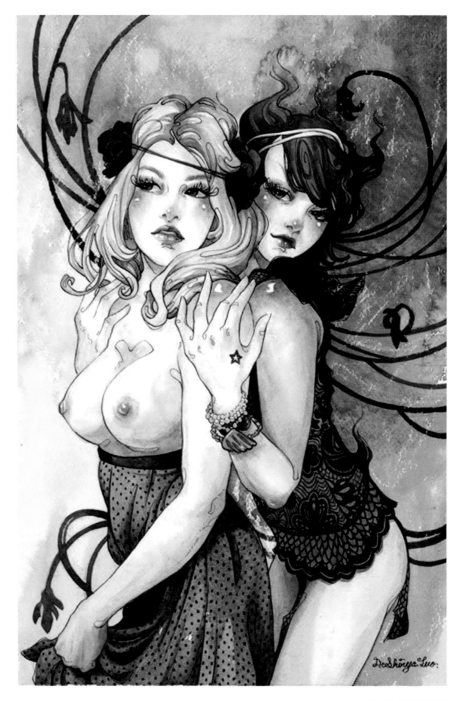

THE GHOST

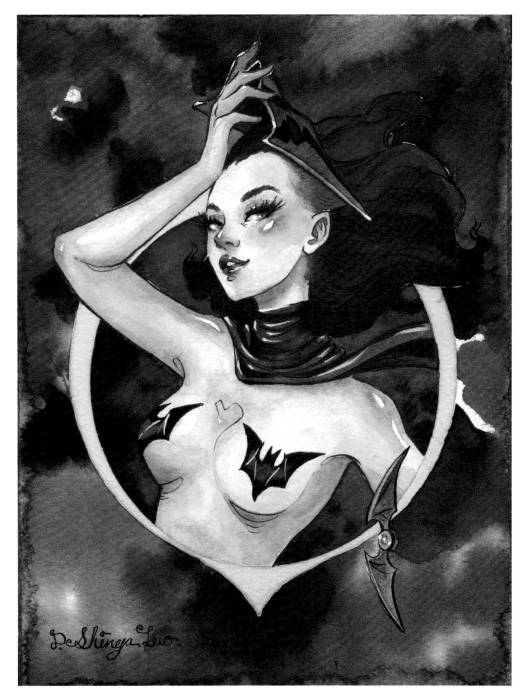

UNDERNEATH THE BATMASK

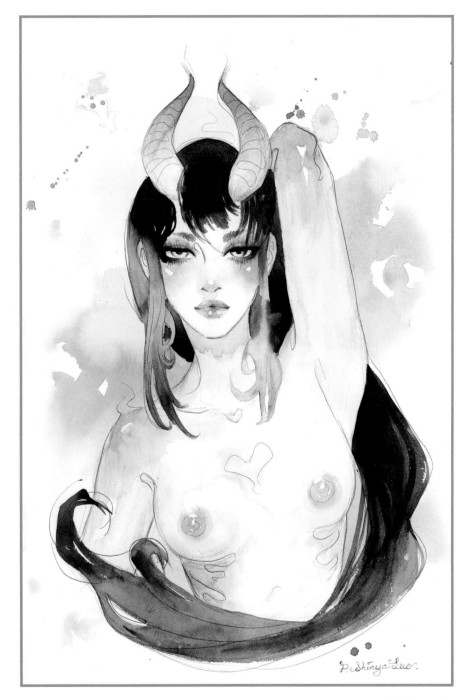

UNTITLED

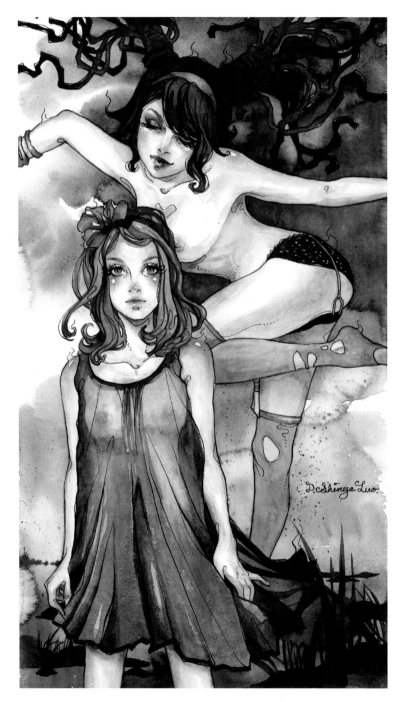

VOICES SHE HEARD

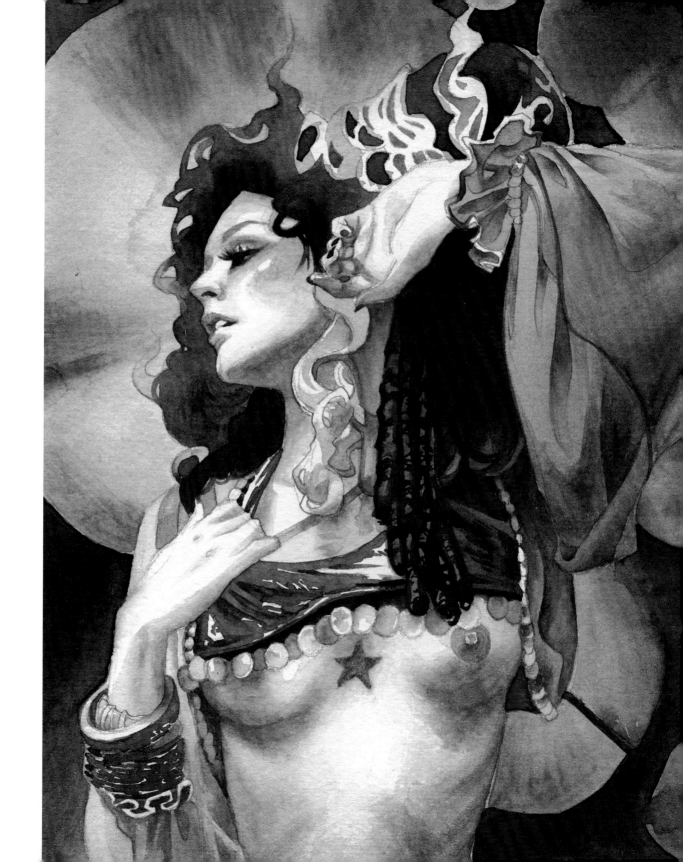

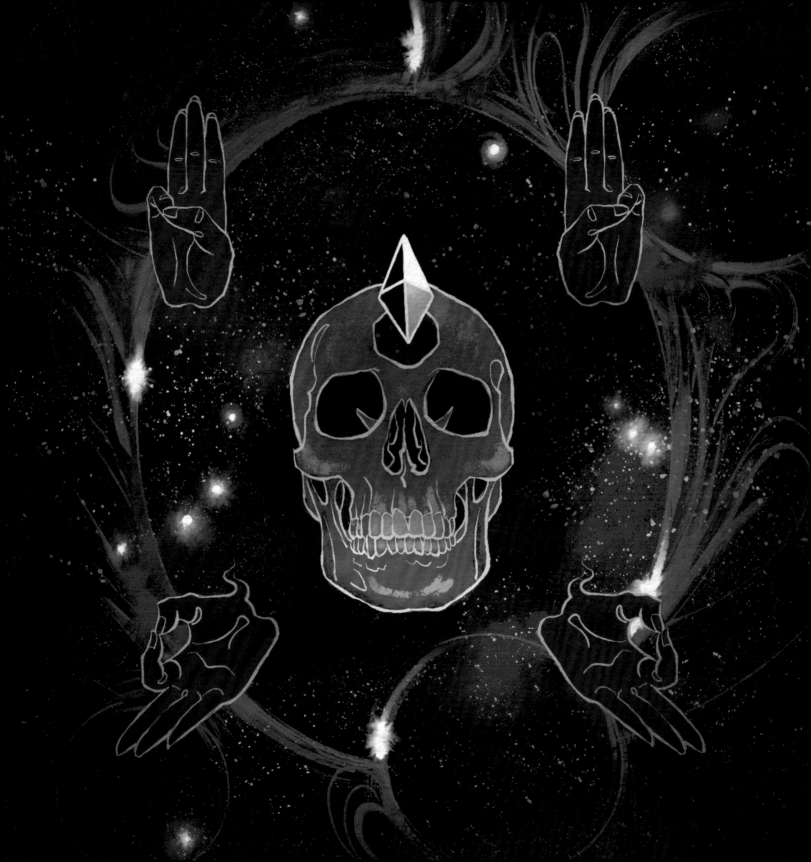

STYLUS ON SCREEN

In 2020, after struggling with a long break from creating any meaningful works, I had the fortune of meeting one of the founders of Async.Art. She introduced me to the idea of digital ownership, which we see now with NFTs. But unlike ordinary NFTs, the tools on Async.Art can create interactive or generative NFTs. Interactive NFT means the art can respond to their owners or time. My mind was blown by the idea that my artwork can visually make responses based on commands of their owners.

Feeling uninspired by what I've always done, watercolor, this became my motivation to make new art. It led to my transition from doing physical watercolor paintings to painting digitally on screens.

The process is similar to physical painting, but executing it meant I had to learn many new things. Selecting the right brushes, picking colors instead of mixing colors, the size of workable area, and all the tools and functions in a software were just the first few things to get use to.

Learning new things keeps us feeling alive. Even though there are many challenges, I'm still beyond thrilled to be stepping on the bleeding edge of art technology.

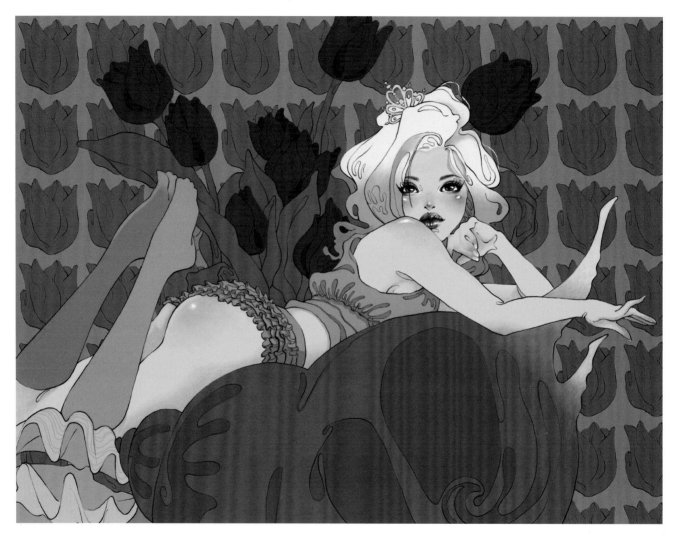

PRINCESS SEASHELL

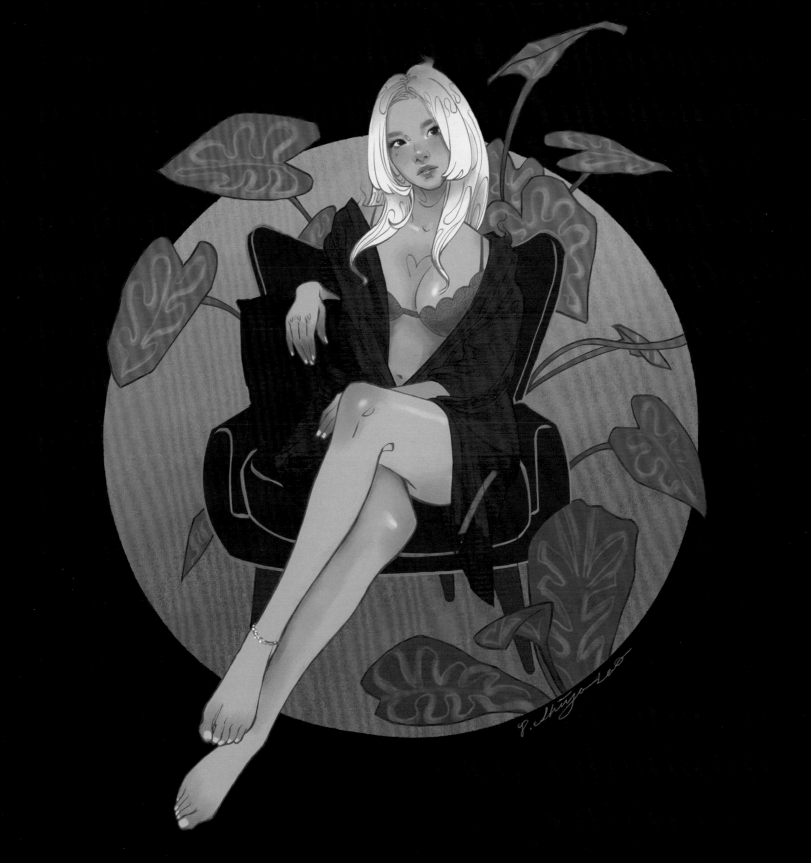

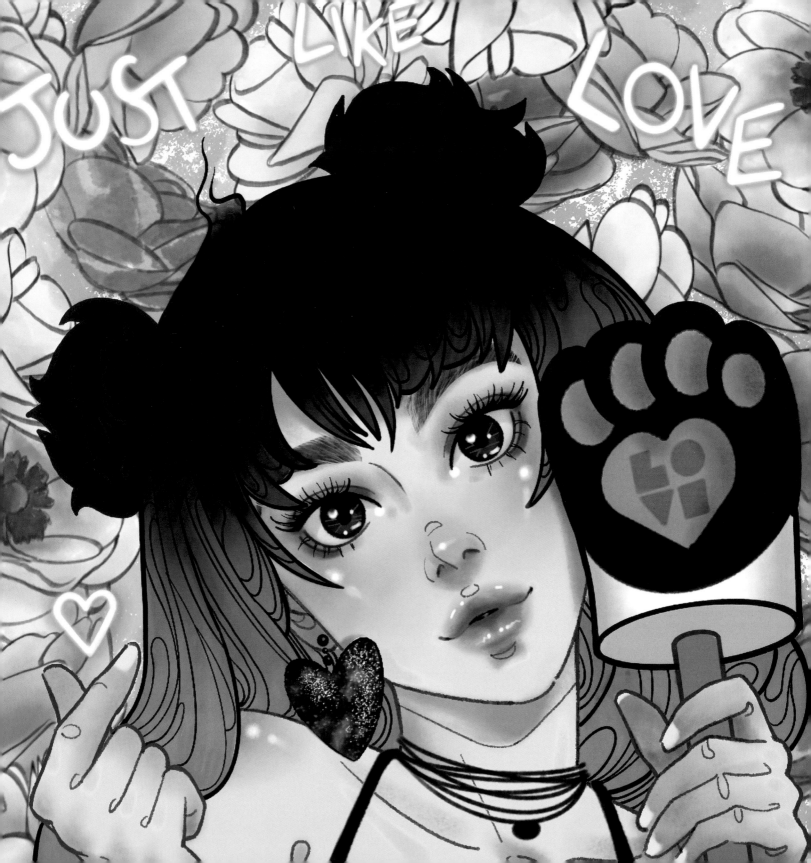

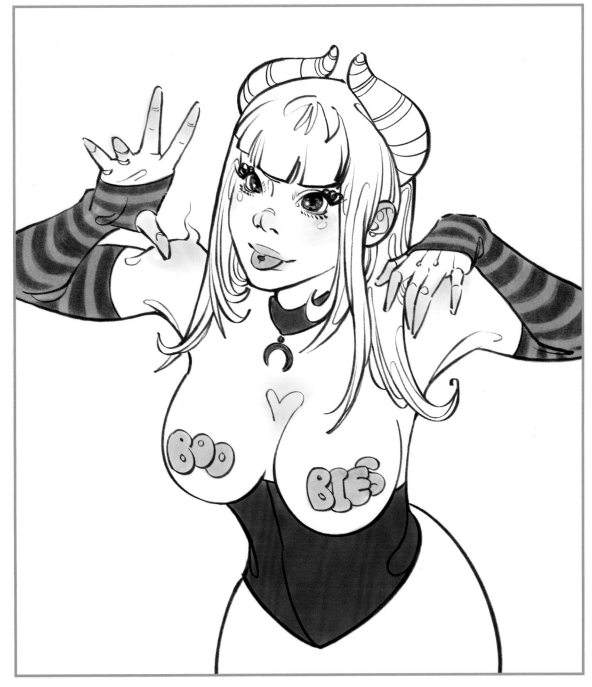

BOO-BIES

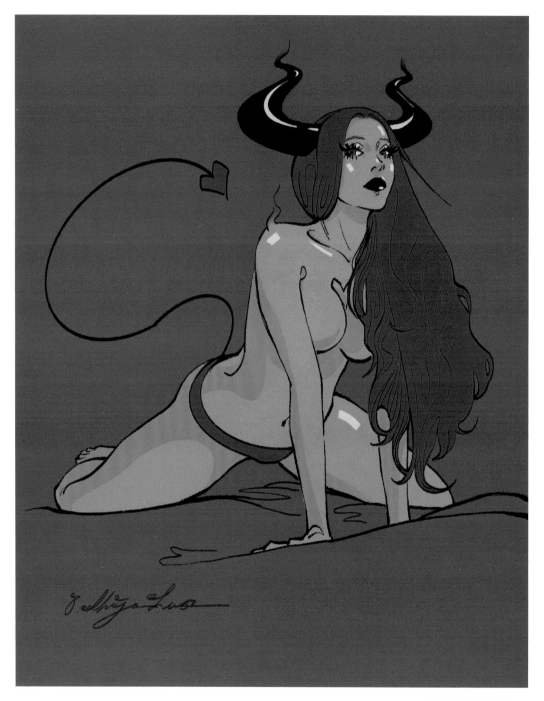

DEMON GIRL I

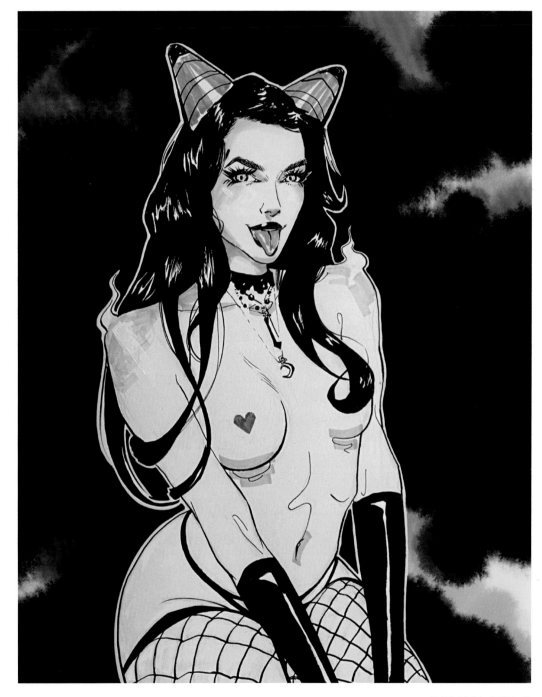

DEMON GIRL II

HIDDEN EVIL

When the night comes,
close your eyes

Let these spirits
be your guide

. . .

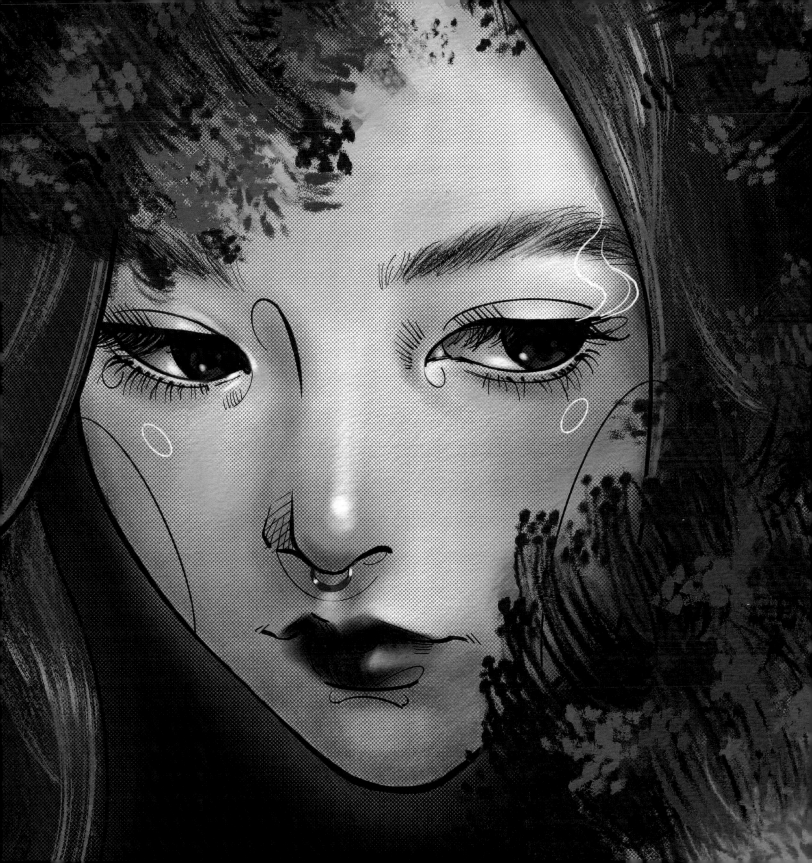

. . .

Sounds of screaming
filled the air

You can run,
but you can't hide

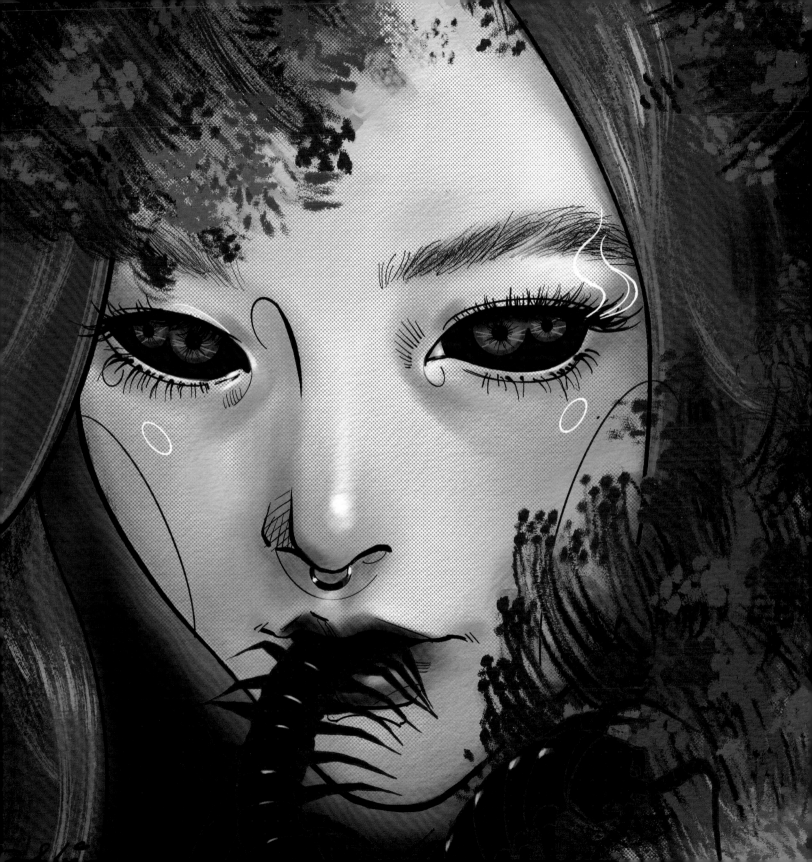

PATH TO NIRVANA

The Path to Nirvana NFT is comprised of 4 layers. These layers stack one on top of the other, representing the layers of our consciousness. Ego being the top, then Super Ego, Id, and finally Nirvana. Owners of this Interactive NFT puzzle must metaphorically and literally dig deep into one's consciousness, pass the Ego and Super Ego, make peace with and accept one's Id, only then can they finally reach Nirvana, the last bonus layer of this art puzzle.

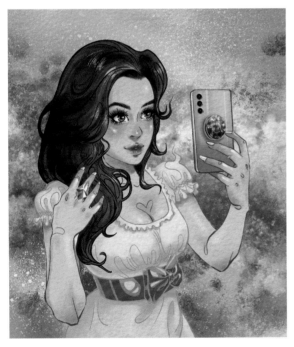

EGO

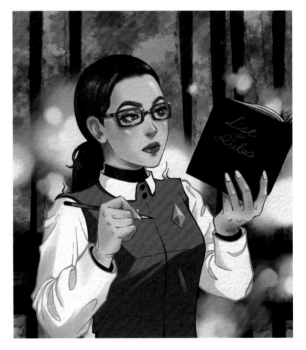

SUPER EGO

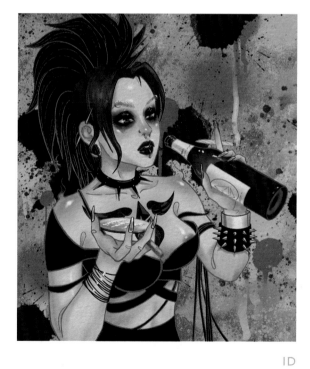

ID

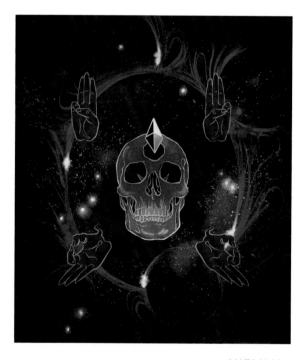

NIRVANA

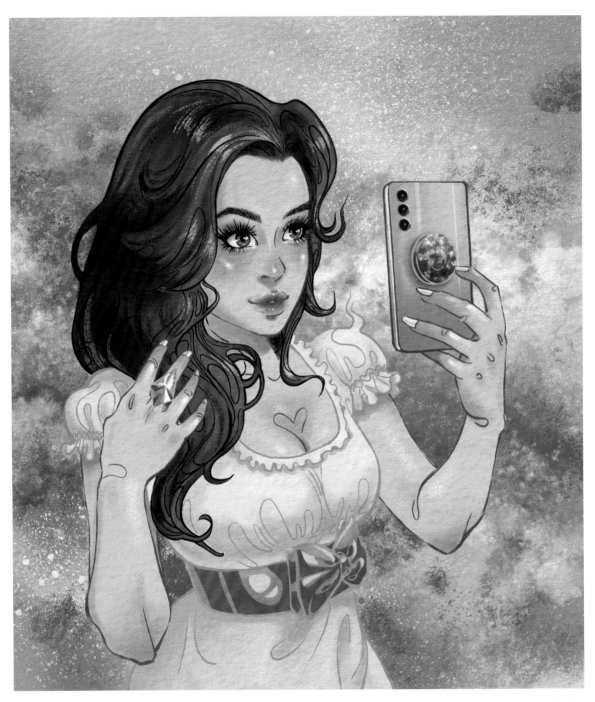

EGO

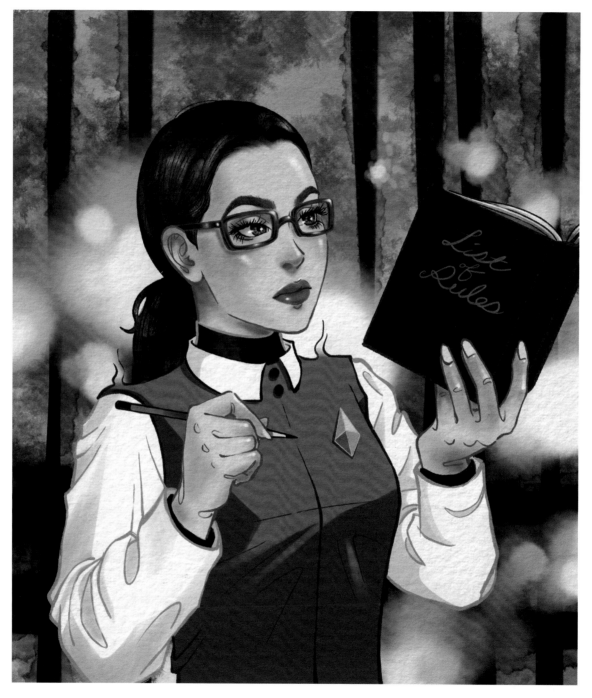

SUPER EGO

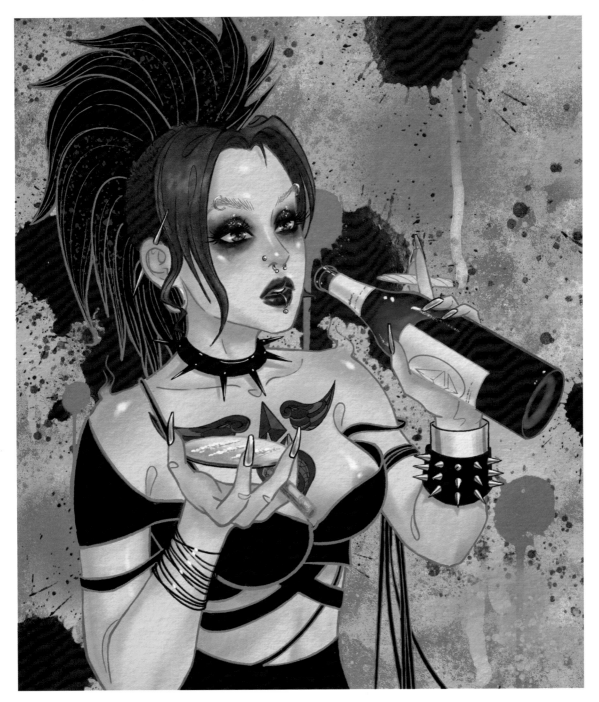

ID

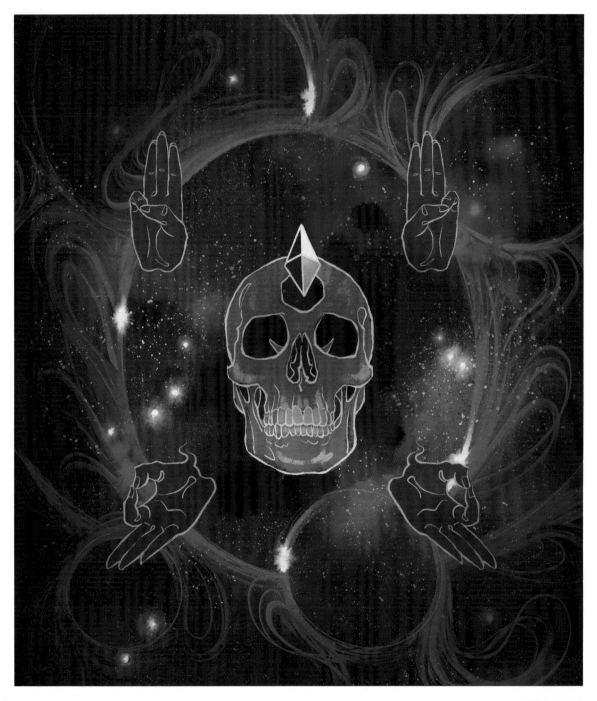

NIRVANA

Everyday I wake up and play
this game called "Life"

It's a simulation

I go through multiple "life lines"
Of different genders, ages,
nationalities

Trying to win the game by
building a successful existence
That ultimately reaches
"Nirvana"

Sometimes, inside the game,
I play games

Sometimes, I fall in love
Sometimes, I die
Sometimes, I make art

But so far
I have not figured out how
to win the game

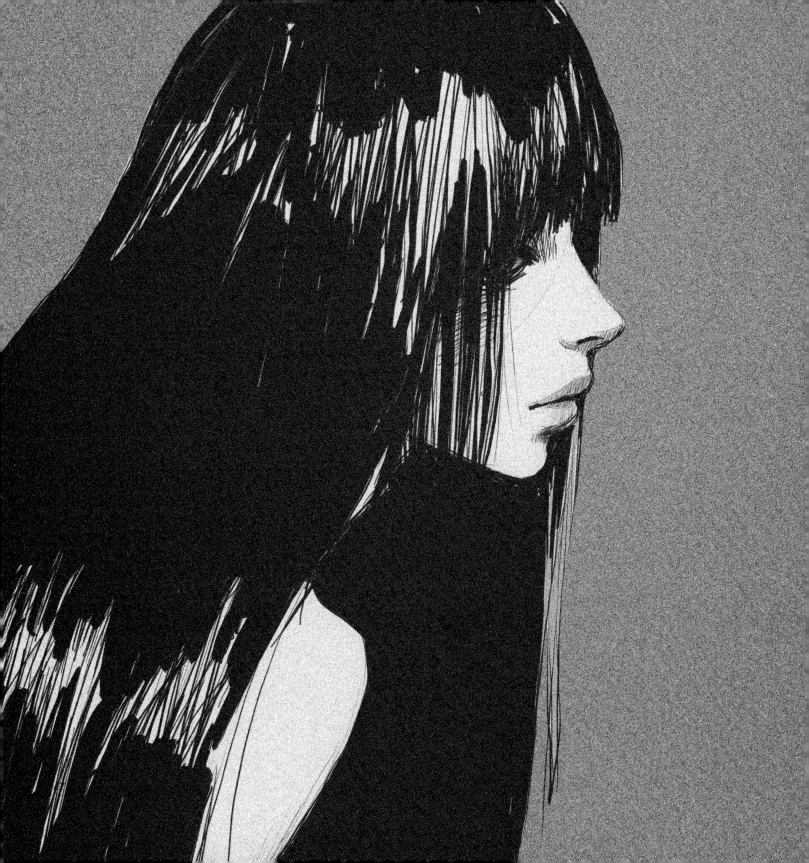

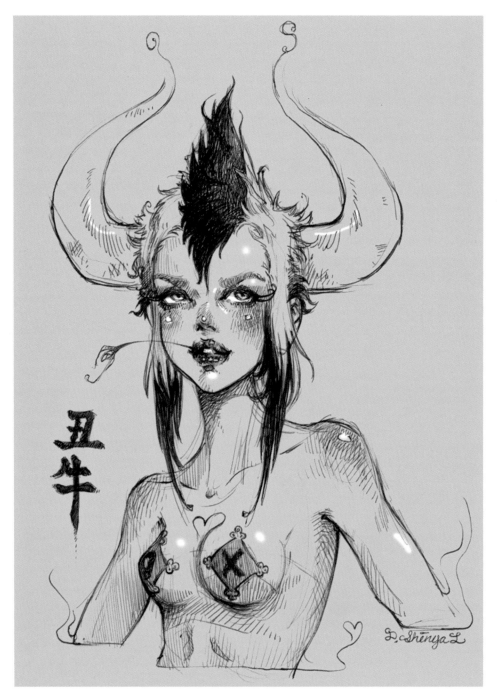

ZODIAC - OX

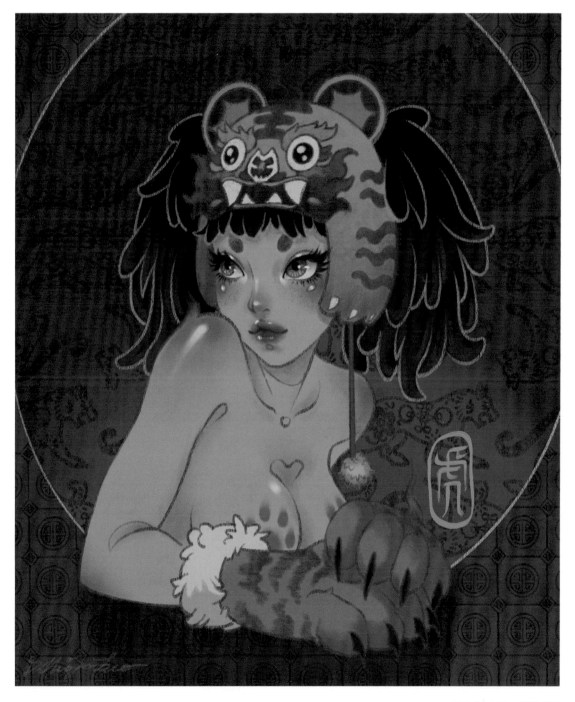

ZODIAC - TIGER

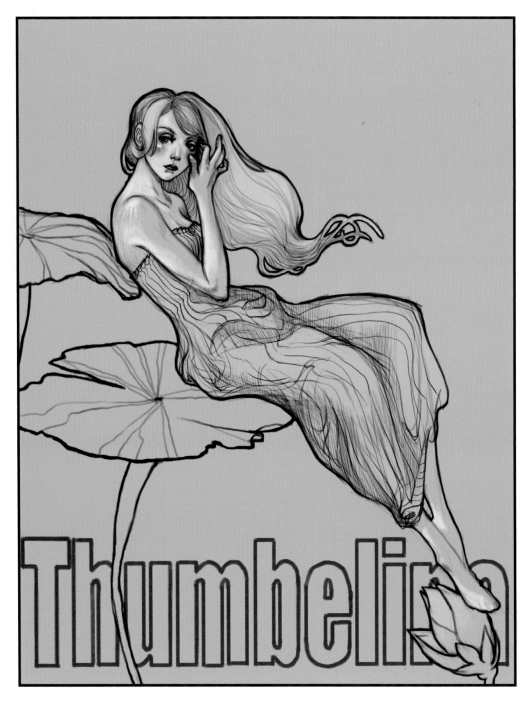

THUMBELINA

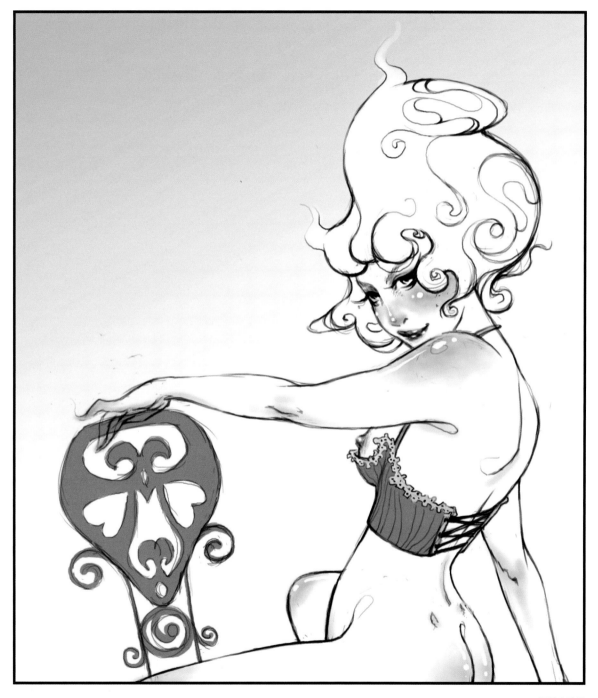

TEASE

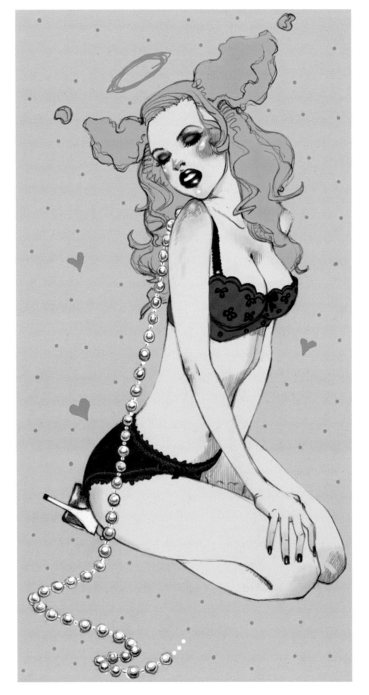

LINGERIE DARLING

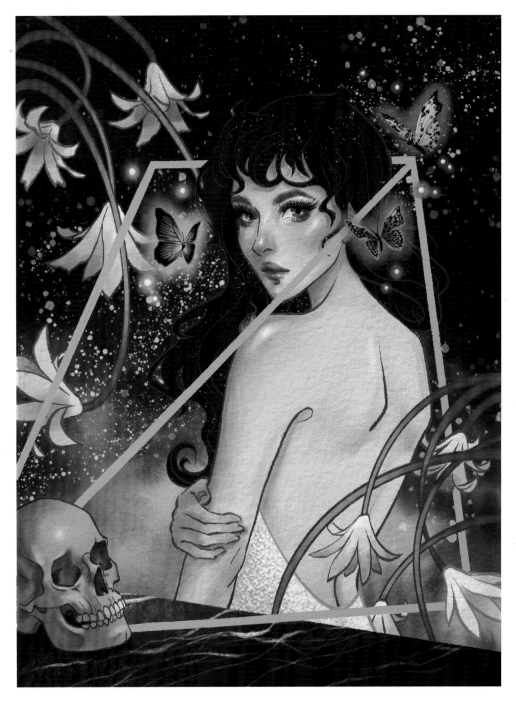

VANITAS THEN & NOW

ABOUT THE ARTIST

When Danni Shinya Luo was living in China as a child, she was always doodling in her text books, and imitating drawings from her favorite Manga pages. After she came to the US, she started taking weekend art classes and eventually got a 4-year apprentice-ship with a well known Chinese-American watercolor master, Ding Ha. Danni went on to study at the Art Center Colleges of Design, graduating with Honors.

Danni Shinya Luo's paintings have been in numerous exhibitions in the US and overseas. Besides her establishment in the pop surrealism field, Danni has been active in other creative fields as well. She has created work for the likes of Hasbro Inc., MGA Entertainment, Nickelodeon Virtual Worlds, Marvel Comics, Zenescope Comics, and more. Danni has also published 3 other art books, Break The Ice, Soft Candy, and Un Petit Catalogue.

In 2020, after taking a pause from the art world to create a little human being, she was introduced to the world of NFTs through the platform Async.Art. This new technology became the spark that reignited her passion for creating, breaking through the limitations of physical processes. She now creates interactive crypto-art using tools from Async.Art, informed by her years of training in traditional media.

Danni has been active in other parts of the art community as well. In 2010, she became one of the featured artists on the documentary film, Comics Are Everywhere. She has also remained one of the original members of GirlsDrawinGirls Inc. for years.

After living in Los Angeles for most of her life, Shinya moved to the bay area in 2014. She now works and lives in her home in the south bay, often traveling between there and her old hometown of LA.

MORE FROM DANNI SHINYA LUO

dannishinyaluo.com

 @DanniShinyaLuo

@LuoShinya

visit asynch.art/u/dannishinyaluo/collection
to view NFTs by the artist available for purchase.

MORE BOOKS BY THE ARTIST

Break the Ice

Soft Candy

Un Petite Catalog